I, etcetera
by Alex Kitnick

Out of self-consciousness, I would feel more comfortable substituting the word "I" with the letter "x," but in a short time "x" would change.
—John Miller

D1571762

Over the past few years there has been a marked use of the I, or the first-person singular, in a broad range of cultural practices. We see it in contemporary art and criticism as well as in literature (more and more, these worlds are feeding off one another), and it goes by any number of names: autobiography, autofiction, confession, epistle, memoir, personal essay.[1] Although each of these forms has its own history and structure (memoir collects memories, whereas autobiography chronicles a life), their convergence in our current moment suggests a common impulse and points to a novel conception of the author.

At some point, the idea of the author offered unity and promised personality; it allowed one to group together artworks or novels and mark a discourse. Using the author as key, one could constitute a body of work, identify intentionality, and locate a psychological point of view. But in the 1960s things began to change: When Roland Barthes pronounced the death of the author, complete oeuvres seemed to transform into sundry assortments of "texts." Writing, too, became a self-effacing activity, with Barthes insisting upon its "destruction of every voice, of every point of origin."[2] (Already in 1966, Sol Lewitt described Conceptual art as an effective

2

way of "avoiding subjectivity."[3]) Out of this wrecking came the birth of the reader, who was now tasked with generating a work's meaning. Many understood this death as a political gesture, a shift in power relations: Not only was the master's voice extinguished, the means of production were redistributed and the canon could now be ransacked, imagined differently. In other words, one could do with texts what one wanted.[4]

If the crisis of authorship stemmed from the field of literary criticism, it also had repercussions for artistic practice.[5] The critic Craig Owens argued that it turned the art of the 1970s outwards toward questions of *apparatus*, a term he borrowed from Robert Smithson that also connected to contemporary political thought.[6] In his essay "From Work to Frame, or, Is There Life After 'The Death of the Author'?," Owens noted that certain artists, such as Michael Asher, Marcel Broodthaers, and Daniel Buren, refused to serve as the "unique source of meaning" for their work and instead examined the systems and conventions—the ideologies—that structure institutions.[7] Not surprisingly, these artists often went about their business in "neutral, impersonal, anonymous" ways.[8] By removing a gallery wall, staging a

fictional museum, or creating a readymade painting, they pointed to the external forces that generate a work's meaning and value. As this shift from work to frame problematized traditional ideas of expression, it also refused a paternal relationship between artists and their work, and in doing so it troubled patriarchal structures, a fact that a subsequent generation of female artists leveraged to their advantage. With her appropriations of modernist masters, Sherrie Levine figured the death of the author as an explicitly feminist gesture, as did Louise Lawler, who offered arrangements of artworks in lieu of her own production.[9] In fact, Lawler and Levine located themselves "in practically every position within the apparatus except that customarily reserved for the 'artist.'"[10] Working as a photo editor, designer, curator, and consultant, Lawler pointed to the social nature of artistic practice by creating discrete works of art that nevertheless had the marks of the system all over them. Artists that followed this lead, such as Andrea Fraser, similarly placed themselves within institutional structures, yet they did so even more explicitly. While Levine and Lawler stayed behind the camera, Fraser made her own body central to her performance.[11] Going forward, it was clear that one had to think the whole complex, and that

that included the artist, too. There was no longer an outside space where one could take refuge. The authority of the author had collapsed, and in its place was a blur between institution and individual, system and self.

One might say that the literature of the '70s anticipated this interpenetration, but here the key term was not "apparatus" but "world." Gathering in the Bay Area under the mantle of New Narrative, a group of writers began to explore questions of desire, sexuality, and class in ways that took sustenance from the first-wave feminist mantra "The personal is political." Dodie Bellamy, Bruce Boone, and Robert Glück, among others, reared on the modernist strictures of Language poetry, tried their hand at producing texts that would accommodate both high theory and their lived experience as queer men and women, and that would destabilize the universalizing voice of the straight-white-male subject as a result. To the partisans of New Narrative, Language poetry's abstraction often felt untenable given the reality of their subject positions. At the same time, they did not want to relinquish its experiments entirely. Glück wondered: "How can I convey urgent social meanings while opening or subverting the possibilities of meaning itself?"[12]

Equipped with the writings of Louis Althusser, Georges Bataille, and Michel Foucault, which Boone gathered from graduate-school syllabi, New Narrative writers proposed the "hybrid aesthetic" of autobiography.[13] "By autobiography we meant daydreams, nightdreams, the act of writing, the relationship to the reader, the meeting of flesh and culture, the self as collaboration, the self as disintegration, the gaps, inconsistencies and distortions, the enjambments of power, family, history and language," Glück wrote in his retrospective text "Long Note on New Narrative."[14] The goal was not so much to record one's own stories as much as it was to write oneself into existence by exploring one's connections to others, and these authors upped "the ante…by weaving their own names, and those of friends and lovers, into their work."[15] Naming names did not simply generate gossip, it helped constitute community; to be called out was simultaneously to be called in.

New Narrative's catholic way of working proved crucial for future queer cultural production outside its reach, especially as the AIDS crisis rendered the "death of the author" ever more real and the forming of alliances ever more necessary. Gregg Bordowitz's 1993 video *Fast Trip, Long Drop* is a case in point. A memoir

montage of living with AIDS, the video trails
Bordowitz into a variety of situations: sick at
home in a SILENCE=DEATH shirt, discussing
his coming out with his parents, and conferring
with a support group. Found footage, dealing
primarily with risk, appears throughout the
video—Evel Knievel flies across the sky on a
motorcycle; a man holds a baby over a ledge—
but Bordowitz combines it with material from
his own archive, including documentation of a
rally organized by the activist group ACT UP.
Set to a soundtrack of klezmer music, a nod to
Bordowitz's Jewish heritage, the video's various
parts come together to form a complex whole.
While often making use of direct address and
frequently confessional in tone, the tape slips
into other modes, including the mock-TV
program *Thriving with AIDS*, which introduces
other versions of Bordowitz's character. The
cumulative effect undermines any coherent
sense of identity. If *Fast Trip* is a self-portrait
or "experimental autobiography," it is also one
that pulls at the corners of the author's ego.[16]
The work speaks of an identity politics that
does not affirm identity but rather makes it
unstable through an excess of identifications.
At the same time, Bordowitz states that he
created this work in the hope that his story

would resonate with others: "I used my own life as material to connect with a larger audience of people," he writes. "I believed that if those experiences happened to me, they happened to a lot of people."[17] Refusing the banner of the "confessional artist," Bordowitz insists that his sharing of experience is done in a spirit of collectivity, not catharsis.

While long vital to strains of contemporary art and writing, the tendency to implicate the author and their world appears ever more prominent today, though the motivations for doing so have changed, as has its form. To put it bluntly, one might say that the politics of representation have given way to a preoccupation with feeling. Bordowitz himself identified this shift in a 2006 conversation in which he noted a transformation in his students' language: "In the eighties, when I started doing my own work, 'I see you' was really important. Saying 'I see you' was about visibility and representation. Regarding issues of race, gender, or sexuality, being seen, being represented, was important. And now I'm just fascinated that my students say, 'I feel you.'"[18] Bordowitz links this shift from vision to feeling to what he describes as "a digital-pharmaceutical complex," a formation that others have explored as well.[19]

Patched together from personal profiles and prescriptions, this new paradigm has fueled the reimagining of writing in the first-person singular. In his landmark study *Sincerity and Authenticity*, Lionel Trilling claimed that the emergence of autobiography in the early seventeenth century owed a debt to "the dissolution of the feudal order and the diminished authority of the church."[20] He also notes Lacan's theory that "the development of the 'Je' was advanced by the manufacture of mirrors."[21] Indeed, today pillars of the social order continue to give way while the screen eclipses the mirror. That said, today's turn to the self, which is likewise an embrace of narrative and text, suggests that the visual no longer represents our current world or our contemporary identities.[22] Oftentimes it seems that feeling and affect have taken the place of the visible, and that the self now serves as a gauge through which systems pass. (The screen, in other words, is not simply a visual technology.) Networked and plugged in, the self makes the vertigo of data concrete, or at least palpable.[23] Indeed, Bordowitz speaks of a recent writing project as communicating "the experience of the 'self as object, not the self as creator.'"[24]

Of course, not all recent work that leverages the I follow this model; other paradigms are operative as well. Indeed, the critic Gary Indiana claims that "the absurdity of memoir as a literary genre is obvious from its recent effulgence."

> Not simply because the conventional memoir is a tidy bundle of lies, crafted to market a particularized self in a world of commodities (complete with real or invented quirks, cosmeticized memories, failings that mask more important failings, self-exonerating treacheries, sins, crimes); behind its costume of authenticity lies the mercantile understanding that a manufactured self is another dead object of consumption, something assembled by a monadic robot, a "self" that constructs and sells itself by selecting promotional items from a grotesque menu of prefabricated self-parts.[25]

For Indiana, the contemporary memoir is cold and calculating, exploiting a system that views difference as little more than the emergence of a new market. He sees the "conventional memoir" as the perfect literary counterpart to an algorithmic sales force that already knows the next movie you'll love before you've seen

it yourself. ("Produce variety and you produce a niche market," Brian Massumi says.[26]) And while the resurgence of the first person is undoubtedly connected to a culture in which so many of our technologies focus relentlessly on the I and on mining everything the self has to give (locations, likes, allegiances, etc.), not all work that begins with the self capitulates to the powers that be. Thus, while many have labeled much recent work narcissistic, the self reemerges in art and literature today not as an absolute origin with depths to be explored but rather as something ceaselessly constructed, mined, and manufactured—a contested site uniquely intelligent about wider systems.[27] Distinct from the Romantic conception of the author as wellspring, the Surrealist conceit that the subject might divulge truth through trance or dream, and the Artaudian desire to obliterate the I, our current notion of the author takes as a given the privileging of individual energies at the expense of common ones in a mode similar to neoliberalism's project of privatization. Today many view the self as the site where creative work must begin. The first-person singular might be more than a symptom, in other words; used *unconventionally*, it allows us to analyze our current state of being, complicate and reanimate

11

contemporary demands, and project alternative futures.

Take the work of Frances Stark, for example. To create her 2011 feature length video *My Best Thing*, Stark fed chat room conversations she'd had with two Italian men into Xtranormal, a crude animation software that, with a minimum of customization, bodied forth two pale figurines, fig leaves atop their "private parts."[28] The digital rendering creates the illusion of presence between "Stark" and her partners—the avatars inhabit the same green Edenic expanse— but the disconnect between their words and appearances conveys the reality of distance. "Are you there? I can't see you," one of the characters asks while standing beside the other.[29] But Stark does not seek to transcend this digital divide as much as she hopes to mine it; indeed, her stilted, typo-ridden conversations, fueled on frisson, bridge seemingly unbridgeable gaps. The artist speaks about an artwork that she has to produce for the Venice Biennale, which leads to discussions of protest and political unrest, of fellatio and family life. (In the end *My Best Thing* became Stark's Biennale contribution.) Work and world share close quarters, which is one of post-Fordism's primary demands. Intimacy is no longer a revolt against the robotic and

spectacular; rather, it is part and parcel of the machine, and this is precisely why Stark uses it as fodder for her practice. As Franco "Bifo" Berardi claims, post-Fordism's new "immaterial factory" undermines divisions between personal and professional, inside and out, by asking us to "place our very souls at its disposal: intelligence, sensibility, creativity and language."[30]

An earlier video by Stark, *Structures That Fit My Opening and Other Parts Considered in Relation to Their Whole* (2006), also negotiates a space between private lives and professional interests in a way that brings New Narrative to mind. Generated from a letter written to exhibition curators, Stark's PowerPoint presentation is filled with snapshots and images of artworks by the artist and her friends. "I'd like to push myself towards a better understanding of what kind of liberation I—as a woman, artist, teacher, mother, ex-wife—am really after," the work states, proposing its author as a complicated palimpsest of subject positions. The work posits Stark as all these things, but it also presents the artist as a character in her own work, and in so doing it opens up a host of complications and intrigues concerning personal lives, moods, and feelings in almost clinical fashion. Indeed, from the beginning of her career, Stark has always

revealed herself in her work, investigating interests that fall outside interpellated subject positions, but in *Structures* she feeds herself into a conventional form, making a corporate tool speak of another kind of body. The combination of the work's presentation on a Mac laptop and its theoretical personal nature (the writings of theorist Avital Ronell make an extended cameo) makes it feel as if a journal entry had been slipped into a promotional meeting, and part of the work's excitement comes from seeing these feelings in the wrong place.

Enjambment of forms is key. Like Stark, Moyra Davey, Maggie Nelson, and Chris Kraus also create a hybrid writing that troubles genre by refusing to write a criticism that stays on any one topic.[31] If, as Oscar Wilde once wrote, criticism is the only civilized form of autobiography, autobiography might be a desublimated form of criticism: Everything comes to the surface. (In his manifesto *Reality Hunger*, David Shields speaks of "a deliberate unartiness" in contemporary art: It is, he writes, "'raw' material, seemingly unprocessed, unfiltered, uncensored, and unprofessional."[32]) Such a method turns on slippage and fixates on the fragment. Personal bits percolate into professional life; high and low mix; poetry

coexists with prose. The work of family-making and that of making artwork cannot be parsed from one another. The I does it all.[33] It multitasks. It performs hybrid functions. It reads and writes, though neither activity is entirely its own; Nelson's writing is highly citational, and Davey often trains her photographic eye on passages of text in addition to writing her own meditations.[34] The latter's frequent recourse to video likewise suggests that picture and text no longer contain all that she wishes them to hold; the one needs the other. *Hemlock Forest* (2016) has a sense of overflow, its parts strung together with voice. Ruminating on touchstone figures, from the Belgian filmmaker Chantal Akerman to the English writer Mary Wollstonecraft to her own sisters, the artist recites prerecorded texts in a halting monotone (an earpiece feeds her the lines) from the enclosure of her apartment, an old sign for interiority. Dissonance and mediation encroach on the space of self-analysis.[35]

The I here is strange to itself, and we see this in Maggie Nelson's work, too, where it shifts in shape. Nelson's *The Argonauts* (2015) tells a story of queer transformation, with bodies morphing through pregnancy, surgery, and hormones and giving life to new bodies that in turn propel novel conceptions of family.[36] An account of

the author's relationship with the artist Harry
Dodge, as well as of her pregnancy, the book
turns on Barthes's comment about the ship *Argo*,
"each piece of which the Argonauts gradually
replaced, so that they ended with an entirely
new ship, without having to alter either its
name or its form."[37] Following Barthes, Nelson
compares this passage to the phrase "I love
you": Each time the expression is built out of
different parts, out of different I's and yous.[38]
That said, Nelson's interest, perhaps even
more so than Barthes's, is in the demands made
on the I, which she, too, considers in light of
social media: "After a lifetime of experimenting
with the personal made public, each day that
passes I watch myself grow more alienated
from social media, the most rampant arena for
such activity," Nelson writes. "Instantaneous,
noncalibrated, digital self-revelation is one of
my greatest nightmares," she continues. Seen in
such a light, *The Argonauts* must be imagined as
an exercise of the self, a way of constructing the
I differently.[39]

The I, of course, is also the central character
in Chris Kraus's celebrated 1997 autofiction
I Love Dick, in many ways the urtext of this new
genre; like Stark's *Structures*, it too constructs
itself out of a feverish, one-sided epistolary

correspondence.[40] The book, in fact, might be considered more of a compilation since it gathers real-life letters actually sent and signed in the author's name; though Foucault once claimed that "a private letter may well have a signer—it does not have an author," Kraus insists that it have both.[41] The letter allows the book to open onto a vast range of topics, including the CIA's involvement in Guatemala, the feminist-art program at CalArts, R. B. Kitaj's Jewishness, and Hannah Wilke's "narcissism." Kraus has made it clear that her method owes a debt to an earlier generation of New York School writers: Theirs "was not an introspective, psychoanalytic 'I,'" she says. "It was an 'I' that was totally alive, because it was shifting."[42] This shiftiness is central to Kraus's technique, as it is to Nelson's and Stark's, but the aliveness and versatility of the New York School writers also feel different from the frenzy one senses in this later generation. "Maybe 1st Person writing's just as fragmentary as more a personal collage," Kraus wonders halfway through the novel, searching for theoretical ground. "It's just more serious: bringing change and fragmentation closer, bringing it down to where you really are."[43] Collage, too, is bodily, it uses scissors and fingers and glue, but the point is that

17

I Love Dick uses change and fragmentation as structural conceits. A kind of chance operation, such a method allows for self-understanding and elusiveness at once. Fittingly, no narrative arc strings the book's episodes together; incidents accumulate, occasionally cutting back and forth between one another, without much sense of future horizon. Crucially, the first person remains the starting point, a place from which to begin again: "I want to make the world more interesting than my problems," Kraus writes. "I have to make my problems social."[44] To put it somewhat differently, she attempts to locate the social dimensions of what preoccupies her.[45]

If *I Love Dick* suffers from monomania, *Torpor*, a later novel by Kraus, centers around a narrative of coupledom and reproduction, even if it is about a couple's inability to consummate their desire. Like *I Love Dick*, *Torpor* is also a memoir, but here it is thinly veiled, a roman à clef, Kraus having swapped out her name for the pseudonym Sylvie.[46] Together with her husband Jerome, a child of the Holocaust, Sylvie spends much of the book dreaming of having a baby, a desire that Jerome meets with a persistent and lame ambivalence. Even so, the two take an extended road trip through Eastern Europe, where, so Sylvie and Jerome have heard, it's easy to get a

child on the black market. Romania, a land in the wake of revolution, might offer a new start. But in Romania, Sylvie and Jerome encounter a country mired in forgetfulness, and they return home empty-handed, left to fabricate stories to mask their far-fetched desire. Leaving Jerome at the end of the novel and relocating to Los Angeles, Sylvie feels better, throwing herself into work and sex with professional vigor. And it is in Los Angeles, in fact, where Kraus made her reputation in the 1990s, teaching at art schools and writing reviews (and *I Love Dick*). If part of the intrigue of *Torpor* is decoding who is who, Kraus's criticism makes it explicit by naming names, rendering the dynamics of a social network in which she played a key part. (The comprehensive reader of Kraus—and there is something about this writing that demands that one read all of it—will notice details from her fiction reappearing in her criticism and vice versa. The web of intertextuality thickens, and this wild proliferation and dispersion of the self might be yet another characteristic of this new authorial mode, as is its tendency to foster a cult of personality. The reader becomes a voyeur, a connoisseur of the author's moods and affects.) As in her fiction, in her critical writing Kraus privileges artists who use their

"life as primary material" while viewing it "at some remove." "There is no problem with female confession providing it is made within a repentant therapeutic narrative," Kraus writes in "Pay Attention," an analysis of patriarchy and paranoia at UCLA's MFA program. "But to examine things coolly, to thrust experience out of one's own brain and put it on the table, is still too confrontational."[47] Her work, of course, does just that.

If some of the writers surveyed here get too close to their subject (a recent anthology of New Narrative writing bears the title *Writers Who Love Too Much*), others, like Kraus, use the "I" to step back from themselves, to self-alienate, both relishing and repulsed by how easily they transform into personas. Both reputation and reception are something an author always brings to her work, though one may conform to expectations or subvert them.[48] Either way, reputation functions as a kind of fiction, which informs, and may be incorporated into, the text. Often called autofiction (a fictionalizing of the self), this brand of writing revisits Rimbaud's claim that *Je est un autre* only to reimagine it differently: Not only is the self discovered out in the world, it is never in one place.[49] It must be gathered and narrated again. Relying on

paratextual sources—previous publications, author photographs, ad campaigns, gossip, and rumor—Ben Lerner fits into this category, and it is perhaps worth noting here that he is one of a handful of men (and a straight white man at that) to make use of a technique largely employed by women.[50] Certainly, while much of the work examined so far, in its insistence on the forbidden and the censored, and in its refusal of shame, serves as a rebuke to patriarchy and carries a trace of what Hélène Cixous called *écriture féminine*, there is nevertheless a difference: Cixous's conception of women's writing laughs in the face of misogyny and oppression; today's écriture faces a situation in which writing is not suppressed but demanded— it often arises from a state of depression.[51] This is not performativity, but disclosure under duress, perhaps desperately so. (The author's name collects things together. She is a search term, metadata, the next step in what Foucault called the author function.)

All of these writers and artists offer a new idea of what life looks like after the death of the author. Whether or not they set out to mine this theoretical terrain, the question of the first person has been thrust upon them by larger social and technological transformations. The

birth of the reader and the articulation of the apparatus are still central (indeed, this work is characterized by a both/and rather than an either/or attitude), but something has happened to the author herself, which has to do with more than a simple return to biography or intentionality or the body. Work has not given way to frame as much as it has been reimagined as a "net of words," and writers are caught in it as much as readers.[52] To a certain extent this new model of authorship has to do with time and the relationship between the author and their work. Whereas Barthes wanted to do away with the past so as to break the connection between author and origin— "Every text is eternally written *here and now*," he claimed. "*Writing* can no longer designate an operation of recording, notation, representation, 'depiction'"—authors today carry their writing like baggage: It somehow precedes them, rather than the other way around.[53] (One might think here of the practices of artists Danh Vo and Ken Okiishi, which meditate on migration and incorporate objects from family histories.) Artists no longer come before their work in order to give it meaning so much as they stand beside it, accompanying it, tied in some vexed relationship to it, and their work often functions as an

account of this relationship. Family, market, and discourse are all given equal weight, and it seems not only impossible but also undesirable to separate these terms from one another; one wonders, in fact, if these key words have replaced traditional disciplines such as painting and sculpture (or even performance and video). While the turn to the first-person singular might have to do with a refusal to universalize, or a skepticism about the ability of describing a system as if one stood outside it, there also seems to be a claim that the best way to give an account of a system's effects—and a "digital-pharmaceutical" one at that—is to articulate how they register on, or as, the self, and not simply the body. Perhaps it goes without saying, then, that such work does not mark a return to intentionality so much as it monitors symptoms. Indeed, in all this work the self resurfaces like a thing repressed; after the millennial excitement around the avatar, in which many imagined eluding power by propagating fictitious entities, the self (which both is and isn't the wealth of collected data about you) is now imagined as a baseline from which work might begin.

Reading all this, one might worry that art's aspirations are narrowing in scope, that they have become too personal, too individual.

Already in the *Salon of 1846* Baudelaire complained, "Individuality—that little *place of one's own*—has devoured collective originality."[54] Certainly, this claim does not appear completely untrue. There is more of the first-person singular today than the first-person plural. If the I now stands for intimacy and interpersonal connection, it is also somewhat shut in, even as more and more people feel empowered to use it. Aspirations seem to have diminished, and an audience may now constitute little more than an imagined community of friends. That said, there is more in this recent turn than "evasion" and "escape."[55] Though an irresolvable tension exists between the I and the network of which it is a part, we see a persistent desire in all this work for the first person to get outside itself and connect with others. The poet Ann Lauterbach is attuned to this possibility: "If the 'I' finds its way out of the egotistical sublime and toward the alterity implied by all imaginative acts, then it will once again initiate paths away from self-absorbed narcissism to a recognition of the linguistic matrix that binds us to each other and to the world."[56] Indeed, a close reading of these artists and writers demonstrates that if their work is born of "a little place," it nevertheless possesses a desire to reimagine a wider world.

Their collective question, to paraphrase Kraus, is how to locate the social dimension of their feelings and imagine new forms of connection.[57]

Notes

1 The founding figures of these genres are also undergoing reexamination. See Sarah Ruden's translation of Augustine's *Confessions* (2017) and Sarah Bakewell's *How to Live, or, A Life of Montaigne* (2010).

2 Roland Barthes, "The Death of the Author," in *Image Music Text* (New York: Hill and Wang, 1977), 142.

3 Sol Lewitt, "Paragraphs on Conceptual Art," in *Conceptual Art: A Critical Anthology*, eds. Alexander Alberro and Blake Stimson (Cambridge, MA: MIT Press, 1999), 13.

4 Guy Debord's *Mémoires* (1959), a chance meeting of text, cartoons, and paint splatters, produced with Asger Jorn, proves the point. One might go so far as to say that the entire neo-avant-garde project refused the author's voice in favor of subversion and critique.

5 Barthes's text first appeared in *Aspen* magazine, in 1967, in an issue dedicated to Conceptual art. For more on this, see

Molly Nesbit, "What Was an Author?," in *Midnight: The Tempest Essays* (New York: Inventory Press, 2017), 9–41.

6 Craig Owens, "From Work to Frame, or, Is There Life After 'The Death of the Author'?," in *Beyond Recognition: Representation, Power, and Culture* (Berkeley: University of California Press, 1992), 122. Owens quotes Smithson as saying that "the growing issue" of the 1970s would be "the investigation of the apparatus the artist is threaded through." Louis Althusser's 1970 text on ideological state apparatuses, and the work of Michel Foucault more broadly, are clearly relevant here. For more on this, see Giorgio Agamben, *What Is an Apparatus?*, trans. David Kishik and Stefan Pedatella (Stanford, CA: Stanford University Press, 2009).

7 Ibid., 123.

8 Ibid., 131. Benjamin Buchloh has argued that the discussion around the "death of the author" was tied to "a general project of de-subjectivization." Benjamin H. D. Buchloh, "Darcy Lange: Paco Campana," in *Darcy Lange: Study of an Artist at Work*, ed. Mercedes Vicente (Manchester: Cornerhouse, 2008), 52.

9 Owens continued this line of thought in "The Discourse of Others: Feminists and Postmodernism," where he refers to Levine's "disrespect for paternal authority." Craig Owens, "The Discourse of Others: Feminists and Postmodernism," in *Beyond Recognition*, 182.

10 Ibid., 135. Owens says much the same thing in a review of Levine's work: "In all her work Levine has assumed the functions of the dealer, the curator, the critic—everything but the creative artist." Reading these activities in light of her appropriation of works by Franz Marc and Egon Schiele, Owens claims Levine's work as a critique of "the recent resurgence of the expressionist impulse." Owens, "Sherrie Levine at A&M Artworks," in *Beyond Recognition*, 114–16.

11 Fraser's earliest performances, *Museum Highlights* (1989) and *Welcome to Wadsworth* (1991), found the artist taking on the role of the museum tour guide. Over time, Fraser implicated herself in ever more searching ways, as in her *Untitled* (2003), in which she performed sex work for a collector, and *Projection* (2008), a two-channel video in which the artist appears in conversation with herself.

12 Robert Glück, "Long Note on New Narrative," in *Biting the Error: Writers Explore Narrative*, eds. Gail Scott, Robert Glück, and Camille Roy (Toronto: Coach House Books, 2004), 27.

13 Glück went on to explore autobiography in his 1994 novel *Margery Kempe*, which used the medieval text *The Life of Margery Kempe*, often considered the first autobiography in English, as a starting point.

14 Glück, 29. Interestingly, Barthes, too, began to explore the genre with the publication, in 1975, of *Roland Barthes by Roland Barthes*, a memoir-in-pieces written in both the first and third persons. Barthes, however, remained skeptical of expression. "Writing subjects me to a severe exclusion … because it forbids me to 'express myself': *whom* could it express? Exposing the inconsistency of the subject, his atopia, dispersing the enticements of the imaginary, it makes all lyricism untenable…. Writing is a dry, ascetic pleasure, anything but effusive." *Roland Barthes by Roland Barthes*, trans. Richard Howard (New York: Hill and Wang, 1977), 86.

15 Ibid., 31.

16 At the same time, Bordowitz is also in search of some sort of agency. "I want to be the protagonist of my own story," he states toward the end of the video. For more on *Fast Trip, Long Drop*, see Roger Hallas, "Related Bodies: Resisting Confession in Autobiographical AIDS Video," in *Reframing Bodies: AIDS, Bearing Witness, and the Queer Moving Image* (Durham, NC: Duke University Press, 2009), 113–50. Many thanks to Mia Lotan for pointing me towards this text.

17 Bordowitz studied with Craig Owens at the School of Visual Arts in New York, and he narrates his turn to the first person as a result of his engagement with institutional critique. "I went from viewing the gallery as a structure to questioning it as an institution," he writes. "Who determined what hung on the walls and why? Who attended galleries and why? Whose interests were being served and what did I desire?" Gregg Bordowitz, "Dense Moments," in *The AIDS Crisis Is Ridiculous and Other Writings, 1986–2003* (Cambridge, MA: MIT Press, 2004), 130.

18 Rhea Anastas, Gregg Bordowitz, Andrea Fraser, Jutta Koether, and Glenn Ligon,

"The Artist Is a Currency," *Grey Room* 24 (Summer 2006), 111.

19 Ibid., 114. Paul Preciado begins his book *Testo Junkie* with this counsel: "This book is not a memoir. This book is a testosterone-based, voluntary intoxication protocol, which concerns the body and affects…. A body-essay. Fiction, actually. If things must be pushed to the extreme, this is a somato-political fiction, a theory of the self, self-theory." Paul B. Preciado, *Testo Junkie: Sex, Drugs, and Biopolitics in the Pharmacopornographic Era* (New York: Feminist Press, 2013), 11.

20 Lionel Trilling, *Sincerity and Authenticity* (Cambridge, MA: Harvard University Press, 1971), 20.

21 Ibid., 25.

22 In 1966, Susan Sontag wrote, "Art, which I have characterized as an instrument for modifying and educating sensibility and consciousness, now operates in an environment which cannot be grasped by the senses…. But, of course, art remains permanently tied to the senses." Susan Sontag, "One Culture and the New Sensibility," in *Against Interpretation* (New York: Picador, 1966), 301. More

recently, Hito Steyerl has also pointed to the challenges confronting contemporary vision. "Contemporary vision is machinic to a large degree," she writes. "The spectrum of human vision only covers a tiny part of it.... Seeing is superseded by calculating probabilities. Vision loses importance and is replaced by filtering, decrypting, and pattern recognition." Hito Steyerl, "A Sea of Data: Apophenia and Pattern (Mis-) Recognition," in *Duty Free Art: Art in the Age of Planetary Civil War* (New York: Verso, 2017), 47.

23 Such an idea might problematize the liberatory promises of performativity often associated with the online world. Melissa Gronlund speaks of the "radical performativity of identity that is assumed within digital culture, where one is taken to be able to (or to have to) generate new identities online, created by postings, links, likes, and one's network of friends. Identity online is produced not by 'ethnicity and family, nation-state and culture, tradition, class and social customs,' but by the cumulative effects of daily activity." Gronlund claims that this has led to a new typology of contemporary art: "Artists

speak… from a standpoint of an 'I,' and often literally so, with the lecture-performance becoming a key genre within post-internet art." Melissa Gronlund, *Contemporary Art and Digital Culture* (London: Routledge, 2017), 28.

24 Gregg Bordowitz, *Tenement* (New York: MoMA PS1, 2015), 39. Bordowitz is quoting the psychoanalyst Thomas Ogden.

25 Gary Indiana, "Guyotat's Coma," in Pierre Guyotat, *Coma* (Los Angeles: Semiotext(e), 2010), 8. Many thanks to Janique Vigier for bringing this passage to my attention. One might compare Indiana's thoughts on the memoir to Pierre Nora's. Nora connects it to a breakup of official history. "In just a few years, then, the materialization of memory has been tremendously dilated, multiplied, decentralized, democratized. In the classical period the three main producers of archives were the great families, the church, and the state. But who, today, does not feel compelled to record his feelings, to write his memoirs— not only the most minor historical actor but also his witnesses, his spouse, and his doctor." Pierre Nora, "Between Memory and History: Les Lieux de Mémoire," *Representations* 26 (Spring 1989), 14.

26 Brian Massumi, "Navigating Movements," in *Hope: New Philosophies for Change*, ed. Mary Zournazi (New York: Routledge, 2002), 224.

27 See, for example, Merve Emre, "Two Paths for the Personal Essay," *Boston Review*, August 22, 2017, http://bostonreview.net/literature-culture/merve-emre-two-paths-personal-essay.

28 Mark Godfrey offers a helpful account of Stark's project in Mark Godfrey, "Friends with Benefits," *Artforum*, January 2013, 159–65. See, too, my "Text after Text," *Parkett* 93 (2013), 66–71.

29 Stark's sometime collaborator Mark Leckey also hooks himself up to systems and talks through his experience of images under the sign of technology. His 2009 performance *In the Long Tail* might be the emblematic work, but his most recent film, *Dream English Kid (1964–1999AD)* (2016), is an actual *Bildungsroman* about technological change. Stark's work has inspired other artists, too. Stephen Prina cites her as an inspiration for his recent project *Galesburg, Illinois+* (2016). See Allie Biswas, "Stephen Prina: 'The exhibition was really about considering whether I

could embark on an autobiographical project that I would deem acceptable,'" *Studio International*, May 17, 2016, http://www.studiointernational.com/index.php/stephen-prina-interview-galesburg-illinois.

30 Franco "Bifo" Berardi, *The Soul at Work: From Alienation to Autonomy* (Los Angeles: Semiotext(e), 2009), 192. In his introduction to the book, Jason E. Smith writes, "This colonization of the soul and its desire—the entry of the soul itself into the production process—spawns paradoxical effects. It transforms labor-power into what managerial theories call human *capital*, harnessing and putting to work not an abstract, general force of labor, but the particularity, the unique combination of psychic, cognitive and affective powers I bring to the labor process. Because this contemporary reformatting functions through the incitement of my specific creative and intellectual powers, I experience work as the segment of social life in which I am most free, most capable of realizing my desires: most *myself*."

31 The same might be said of Douglas Crimp's recent book *Before Pictures*. "I resisted University of Chicago's interest

in putting A MEMOIR on the cover," Crimp has said. "For me, it's a hybrid. It has autobiographical elements in it, but I wasn't attempting to reconstruct a past in a memoir-like way. It is based on these things I did during the first ten years I lived in New York, like working at the Guggenheim or at *ArtNews*, but I always thought of it as a critical project, too." Sarah Cowan, "Before Pictures: An Interview with Douglas Crimp," *The Paris Review*, November 8, 2016, https://www.theparisreview.org/blog/2016/11/08/pictures-interview-douglas-crimp/.

32 David Shields, *Reality Hunger: A Manifesto* (New York: Vintage, 2011), 5.

33 In its emphasis on mothering, the work of Kraus, Davey, and Nelson calls Mary Kelly's practice to mind, especially her *Post-Partum Document*, and yet we see a difference here as well. "Although it is a self-documentation of the mother-child relationship, here between myself and my son, the *Post-Partum Document* does not describe the unified, transcendental subject of autobiography, but rather, the decentered, socially constituted subject of a mutual discourse," Kelly wrote in 1977. In a 1982 interview with Paul

Smith, Kelly continues, "I suppose that the diaries give a place to the mother in terms of the subject 'I'; she speaks in the first person. But that's displaced by the metadiscursive style, which enters by way of the footnotes and which uses the third person as the dominant mode of address. So I'm not really privileging the autobiographical discourse—I'm always attempting to disrupt it." See Mignon Nixon, ed., *Mary Kelly* (Cambridge, MA: MIT Press, 2016), 4–5, 11.

34 Davey has also dealt extensively with questions of reproduction and parenting. See Moyra Davey, ed., *Mother Reader: Essential Writings on Motherhood* (New York: Seven Stories Press, 2001), and Moyra Davey and Maggie Nelson, "Yours, Truly," *Artforum*, August 24, 2017, https://www.artforum.com/slant/moyra-davey-and-maggie-nelson-in-conversation-70590.

35 Wollstonecraft also figures prominently in Davey's 2011 video *Les Goddesses*. About this work Iman Issa has written, "Her often repeated 'I' didn't come across as the 'I' of a therapeutic self-portrait, or the timid and humble 'I' of a self-reflexive gesture. Davey's 'I' felt more desperate, more like a last resort." Iman Issa, "Best of 2012," *Artforum*,

December 2012, 120. Davey writes about *Les Goddesses* as representing a return to the human figure (and, importantly, her figure) in "Caryatids and Promiscuity," *October* 158 (Fall 2016), 19–29.

36 Moira Donegan claims that one of Nelson's primary concerns is "how to resist the unhelpful demonization of motherhood, domesticity, and the other supposedly reactionary forms that love can take." Moira Donegan, "Gay as in Happy," *n+1* 23 (Fall 2015), 162.

37 Barthes, *Roland Barthes by Roland Barthes*, 46.

38 Barthes writes of the quicksilver nature of the I in "The Death of the Author": "Linguistically, the author is never more than the instance writing, just as *I* is nothing other than the instance saying *I*." Barthes, *Image Music Text*, 145.

39 Maggie Nelson, *The Argonauts* (Minneapolis: Graywolf Press, 2015), 60–61. Ben Lerner has written incisively on similar questions in Nelson's poetry, which he compares to the new lyric mode employed by the poet Claudia Rankine. See Ben Lerner, "After Difficulty," in *The Fate of Difficulty in the Poetry of Our Time*, eds. Charles Altieri and Nicholas D. Nace (Evanston, IL:

Northwestern University Press, 2018), 135–41.

40 The device of folding one's letters into one's fictional work owes a debt to Kathy Acker, who deployed a similar technique in her novels. Kraus has also used the epistolary form in her art writing. See, for example, her letter "Whole," addressed to the artist Julie Becker, in Chris Kraus, *Video Green: Los Angeles Art and the Triumph of Nothingness* (New York: Semiotext(e), 2004). It also seems worth mentioning that Davey has mailed her photographs to friends and colleagues.

41 Michel Foucault, "What Is an Author?," in *The Essential Foucault*, eds. Paul Rabinow and Nikolaus Rose (New York: New Press, 2003), 282.

42 Giovanni Intra, "A Fusion of Gossip and Theory," artnet.com, http://www.artnet.com/magazine_pre2000/index/intra/intra11-13-97.asp.

43 Chris Kraus, *I Love Dick* (New York: Semiotext(e), 1996), 137.

44 Ibid., 202.

45 Where Kathy Acker also used the I, she sought to test it by suffusing it with what she called "fake autobiography." "I wanted

to explore the use of the word I, that's the only thing I wanted to do," she told Sylvère Lotringer. "So I placed very direct autobiographical material, just diary material, next to fake diary material." Eventually, though, Acker claims the I became a "dead issue" in her writing because "you make the I and what makes the I are texts." Kathy Acker, "Devoured by Myths: An Interview with Sylvère Lotringer," in *Hannibal Lecter, My Father* (New York: Semiotext(e), 1991), 7, 11.

46 Kraus borrowed the names of her characters from Georges Perec's farcical 1965 novel *Things*.

47 Kraus, *Video Green*, 63.

48 In his interview with Kathy Acker, Sylvère Lotringer claims, "One way to make your work legitimate…is to work it through your persona. If you are not the I, but the I becomes you, then you have to offer it as some kind of performance." Acker, "Devoured by Myths," 20.

49 Édouard Glissant cites Rimbaud in relation to his concept of errantry. See Édouard Glissant, *Poetics of Relation*, trans. Betsy Wing (Ann Arbor: University of Michigan Press, 1997), 15.

50 Although told in the third person, Seth
Price's novel *Fuck Seth Price* also fits into
this category. Here, the protagonist is a
sinister figure who, amidst meditations on
contemporary art, commits the occasional
murder. The book describes an artist
who makes work strikingly similar to
Price's, and who we assume must share
similar quandaries: "If his paintings were
provocative, it was because they drew out
acute and omnipresent cultural toxins:
anxieties about cynicism and selling out,
feelings that had everything to do with how
fucked-up it was to live under neoliberal
free market capitalism." It's more than
self-implicating: It's self-indictment. That
the author's name only appears on the front
cover in the space of the title suggests that
author and work have collapsed into one.
Seth Price, *Fuck Seth Price* (New York:
Leopard Press, 2015), 19.
51 Hélène Cixous, "The Laugh of the Medusa,"
Signs, vol. 4 (Summer 1976), 875–93.
52 I borrow this phrase from Virginia Woolf,
who used it in a letter to Vita Sackville-West.
*The Letters of Virginia Woolf, Volume III,
1923–1928*, ed. Nigel Nicolson (New York:
Harcourt Brace Jovanovich, 1977), 529.

53 Barthes, *Image Music Text*, 145.

54 Charles Baudelaire, *The Mirror of Art*, trans. Jonathan Mayne (Garden City: Doubleday, 1956), 126. Emphasis his.

55 Siegfried Kracauer uses these terms in his essay "The Biography as an Art Form of the New Bourgeoisie," in *The Mass Ornament: Weimar Essays*, ed. Thomas Y. Levin (Cambridge, MA: Harvard University Press, 1995), 104.

56 Ann Lauterbach, *The Night Sky: Writings on the Poetics of Experience* (New York: Viking, 2005), 39.

57 The title of this essay comes from Susan Sontag's 1978 book of short fiction *I, etcetera*. Many thanks to Hal Foster and Carrie Lambert-Beatty for their close readings of the text.

We Bare Our Souls
by Anne McGuire and Mike Kuchar

Here I stand
A traveler
With footsteps engraved
On the dust of yesterdays
Now struggling with his
Inner noise

44

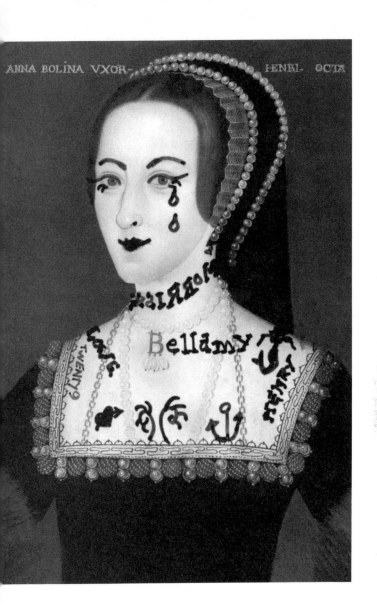

Shadows surround me
Follow me
Room to room
In the depths of this night
There is a vampire
Who enters my veins

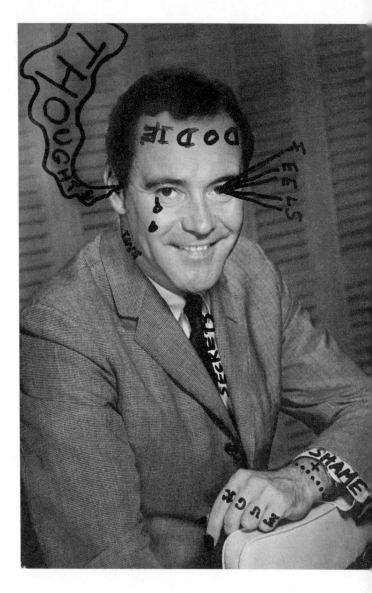

52

54

You're in writing mode when you're listening to Neil Young's *Live at Massey Hall* (1971) version of "Down by the River," and he sings, "She could drag me over the rainbow," and you start crying. Because you just know.

I was planted here

a flower rooted in the bad soil of a dirty time

57

October 6
Fucked, A short poem.
Well, yesterday was my birthday
and I didn't get fucked.
However, today – the whole
country did.

Stretch out night is slanting towards sleep

Starlings
by Lisa Robertson

for Laura Broadbent

Whilst the Communistic Fox

Merrily Becries

Its Fuck

Translucently we Brood

Adoring our Own

Erotic Gravitas

–

This is a General Geophysiology of Wildrose, of
 Starling, of Deer, of Fox, of Laurel, of River

Everything shitty and riming and poor and
 resourceful

This is a work of uncountrying

An ointment

–

Yesterday I cried. It was artless and good.

Spring has its own agony, truly

It involves convolution

For the nudity of one kiss

Joy suffers measure

How tiring it is to disagree with everything!

Then we go visiting, throw our tender runners

Over forest-rim

Starlings. We are breaking into a vast derelict space.

We are the Starling scene in Sterne's *Sentimental Journey*.

A caged Starling is repeating in the voice of a Child "I cannot get out."

—

Call rime a banner of rosewater. Know

any girl will flood the sign with her

sex. Say the refrain, like a flower, fits

in your head. Now you are

flower-sized. Your vocal parts especially

are flower-sized

–

Some were at the edge of language so

couldn't live. Some were at the core of

language so couldn't live either. What

if we forget about language, move into

the natural history of the idea

of guts? Guts or rosewater, very

similar. Rosewater or rime. Uncountrying

by means of rosewater. To make a natural history

of rosewater, penetrate

borders

—

Last night I thought that I would die

my heart ached so darkly

beneath the leftside ribs

but now I think I will not die

relaxed in my stained coat in the ankledeep meadow

I would like to trill a little

and I would trill until sweetness

comes rime furor with form

also shyness with

form (Laura there is

no contradiction

in rime)

_

A hoop-shaped piece of wood that forms the
 outer edge of a sieve

genetically originless

surface of water

the outer ring of a wheel where

the revelation takes the form of a dream

forget the dream but remember its moral
 character a

circular mark or object

a lip

where there's desire to represent

not a catalogue in the encyclopediac sense

but a revelation

a caul

a pellicule

a leather strap or thong

the perenium

sea-rim

–

Laura

are you related to nettle

and fig are you a two-sexed salve

of code-riffling incident are you

ready to speak into time deeply are

you ingeniously fluorescent

enamoured of the poverty of tiny

tiny Europes shall you quit so

many

stupid apartments filled with stupid

fate evade

timeliness next

a refrain unclasps

how it was to be young and carrying our delicate
 grammars

in cities and airports

Laura

let's be Starlings

–

Mozart had a Starling

called Labour, Debt and Atonement

there is no Starling in Ovid

just a low-slung ferocity

Pliny knew a Starling

that spoke both Greek and Latin

Spring seizes the Latin

of the universal convolution

now for my inexperienced style

where the relation of the subjective vocal elements

to what is called More Love Hours

remains incomplete

because the poem makes knowledge without a
 subject

so outside governance

the troubadour Marcabru sends his Starling to
 his Lady

the Starling returns with bad news

her glorious dress is inconstant

I will call language the forbidden attempt to
 codify

ecstasy itself very pleasurable—the attempt I
 mean—

against which there exists the practiced and
 transmitted synaesthesia

of cognition and caress

–

Like the Indent of Acanthus

The Fox of Joy

Tears into us

Freshly

–

The tear is unlimited

because materially it doesn't exist

though it has a complexion

Why is time a genius?

the great force it takes to bring the disappearing
 elements together temporarily

ongoing avoidance of that force

everything I think about

transforms to murmuration

there have been evenings

but never poems

you never just sing but augment

you enter the freshness in your brindled coat

go robustly

greet sweetness

at day-rim your calls are fields of attraction

–

Don't waste this erotic day

your uneven survival

bound into pattern

in evasion of subordination

the evening draws to it

the possible intellect

by sequined sash

Go

verse of no worth

blurred track of a transhumance

plough your thick page

morally resplendent

under cover of mist

total moral abundance

that is

–

Gold-green morning top-branch now violet

flank or breast beneath now rime will come

in an expansion in which the poem

is the opposite of the state

all exactitude and fur of motors

in clenched silk adoration

with extraordinary insolence

it was called distance when

when snow stayed in the morning

the deer came down to feed

the migrant frame of a volubility

moving through laurel

is a matter of eloquence

where the song persists in simultaneous times

and so evades measure

poor song

whose glorious dress

–

Because love levels

I made this verse

like Starlings make dusk

after pause in laurel

they weave to the river

I feel that I work now in the service of their
 amplitude

Speak, super-excellent leaf

ointment of leaf also

as day disappears

in the nudity of verse

dark blooms on water

over the still mirror of water

love moves the bright shadow

unclasps a migration

in the suspension of force

–

Little wandy tree

shimmering by clairvoyant steam-vent

you understand the perfections

of what the evening is concealing

you crave the song

whose frothing exile

rumpled and haughty

with archaistic bulging

you want the ointment

with spiral fluting

called distance when

ah liquid tonic

with 14 terminal and 12 inner rhyme-sounds

such overpowering sweetness

beneath any mothertongue

is a singing suppressed

–

Could it be that there are no Starlings

In the current Belief?

Could it be

There's no Nocturnal Dome?

No

Laurel again? No Adoration?

The Vulgate Gapes.

–

What is hidden and revealed of sweetness in the

vocable whose limpid intuition

in anarchic obedience

by means of rime's complexion

pours

its ambient celebration

Laura

your practice of spiritual liberty

unlaces borders

makes indent of acanthus

you are communal

bare and ample

–

Little swaying wandy top-branch of

winter's visual texture of neglect

in skirtlet of breeze

against the meter of labour

to give likeness freely

people do amazingly things

they sing frequently again

laced through with pattern

fleck resistance with desire

also desire with resistance

in sparkling frock of trance

the opposite of the end-call is esoteric

like being spoken by a super-interesting branch

–

When I try to hear again

the voice of my grandmother

or the voice of Arnaut Daniel

their voice is my body

so I study

poorest twigs poorest words

find emotion in morphology

in its ripest sonourous parts

in rime where a turn is discernable

we should return to the synaesthesia of
 sweetness

brassage, Simone Weil called it

speaking of the mixed people of the pays d'oc

because the language/speech distinction

repeats the fundamental dynamic of governance

Against this distinction the refrain

decorates poorness

for the nudity of one kiss

the tip of the poem flourishes in other times

tip of the body

improvised

–

In my work with poorness

This is what I learned how to make

I hear in these letters

a slab of hot light

emptying from rock-flank

now it slips downward

and I sense that the earth is an animal

by its mauve heat

To sip strangeness freely

is day's good

quietly it courts its rim

where the value called joy suffers no debasement

the revelation takes the form of spit

sweetness is one of time's own names

sweetness or rosewater

when the days first become long again

we are thirsty

–

Maybe rime revolves into the infinity of

linguistics whose thirsty lip

with the rarity of tenderness

braids largesse and light

in the unfettered reception of a civil intimacy

its eveningness relaxed

–

Because Love levels

I made this Verse

Like Starlings make Dusk

After pause in Laurel

They weave to the River

–

A Situated Moment of Strain
by Nicole Archer

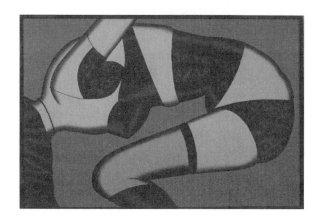

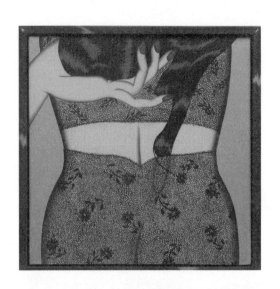

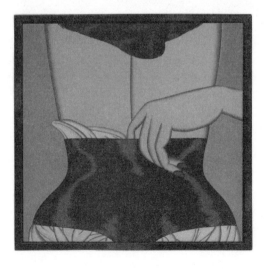

100

I like looking at Christina Ramberg's paintings, particularly in times such as these. Amid the Trump administration's zealous investment in patriarchal power, with its attending forms of toxic masculinity and sexual violence, I seek not solace but a thorny kind of critical pleasure in her work. In the face of a popular mediascape that shamelessly degrades and oversimplifies women's variable sexualities, these frank images map onto my own complex experiences of sexual power and pleasure in ways that are difficult to put into words. They resonate with me—the smooth, polished textures; flawless lines; and deeply feminine intimacies.

The pleasure derived from these images is not simply scopophilic, it also lies in the ability to see past her paintings as images. For the initiated, Ramberg's work offers access to a multisensory sexual discourse that is uniquely shared by those who have poured themselves into corsets (where soft bodies are rearranged into hard objects of desire) and those who know what rough, rigid lace feels like when it is pulled taut between one's legs, cutting sharply into hips. It graphically acknowledges how feminine sexuality is secured through learning to withstand one's own image (as a sexual object), while simultaneously maintaining the desire to

101

retain possession of a specific, embodied archive of erotic experience and capacity. Artworks like *Shady Lacy* (1971) explore how the tightness of a garment engineered to fetishistically suppress the particularity of one's body can offer distinctive opportunities for us to be corporeally present to ourselves. It forges odd, queer bonds between those femmes who know the satisfaction of pulling a long, disobedient lock of hair from the tight waistband of a body shaper—how the zip of these interminable tresses reassures us that we persist (with all of our idiosyncrasies), underneath layers of punishing Lycra.

Ramberg's works do not deny the complex ways in which feminine sexualities are often overwritten and overdetermined by masculinist fantasies, yet they manage to resist the tendency to present such sexualities solely within the terms of objectification and victimization. Her work recognizes how utterly powerful it feels to transform one's body into something to be desired, without sacrificing the onerous and deeply gendered knowledge that this transformation often comes at the price of one's own subjectivity. Her images attest to the complicated fight for (self-)recognition that many of us must engage in, should we hope to lay any sort of claim to our own bodies, pleasures, and experiences.

Ramberg presents an inescapably vivid sense of the material substrates that organize untold women's bodies in their pursuits of pleasure, but she refuses to submit these conventional erotic vocabularies to a clear order of experience. Paintings like *Waiting Lady* (1972) neither justify sexism nor render their protagonists as heroic martyrs in the battle of the sexes. Despite the bold, stylistic resemblance to a comic book panel, Ramberg's "waiting lady" doesn't occupy the mythic time of a superman; instead, she inhabits a situated moment of strain—one that is caught between submission and authority. An image of im/mobility, the painting is as ominous as it is expectant. As viewer-voyeurs, we are ultimately unable to determine whether the painting's central figure is pining to be let go from a truss or waiting to leap up and flip her hair with all the prerogative of a dance floor diva. *Waiting Lady* challenges its viewers to grapple with their own tendencies to see "ladies" as (in)capable of possessing power, or their assumptions that sex must always be accompanied by acts of gendered violence. As the art historian Dennis Adrian notes in an essay written for Ramberg's 1988 retrospective at the Renaissance Society, "The possibilities we both construct from the evidence we are given

[in *Waiting Lady*] and which arise out of our own minds always present more than one possibility, and the emotional tones of these possibilities may present very high contrasts…. This kind of experience is very rich emotionally if fascinatingly uncomfortable."[1]

Ramberg's images are, indeed, uncomfortable. Her paintings address those feminine pleasures that are flagrantly rooted in the rituals and material cultures of heteropatriarchy, which suggest pleasure absolutely requires pain as its counterpoint. They ride a razor-thin line between critique and conformity, defying simple interpretations, while insistently corroborating just how much the personal is imbricated with the political. In the eyes of certain beholders, Ramberg's works appear as proof that one can find pleasure not only in spite of oppression but most poignantly in the critical reclamation of the terms of subjugation. Cast in such an unabashedly third-wave light, Ramberg's tightly cropped figures appear as icons of resistance, and her restrictive undergarments offer a striking sense of empowerment. However, when viewed through a less recuperative lens, Ramberg's equivocal paintings insist that we recognize the extent to which so many women learn to experience pleasure *only* as an attending after-effect of their

objectification. They provide uncomfortable yet crucial clues to the vexing question of why so many white women voted against their own interests (as women) and chose to support a misogynist like Donald Trump in the 2016 US presidential election, and beyond. For many such women, severing their attachments to patriarchy would risk severing their only access to pleasure.[2] And in a world designed to capitalize on our individual and collective exploitation, few things are worth defending more than one's access to pleasure.

One is reminded of Roland Barthes, the critic and unflinching critical hedonist, whose work aimed to demonstrate how "pleasure is linked to a consistence of the self, of the subject, which is assured in values of comfort, relaxation, ease."[3] Like Barthes, Ramberg understands just how tenuous the consistency of pleasure is, how easily its production can be disrupted or transformed, and how revolutionary these everyday slippages are. The implication of paintings like *Waiting Lady* is that political change *must* be accompanied by radical alterations to how we recognize and experience sexual pleasure, how we are introduced to erotic vocabularies, and how we bring certain sexual grammars into play. Her work invites us

to imagine a world where women don't default to the position of sexual object, and where the knowledge gained from reshaping one's body might be directed toward reshaping the world.

As Ramberg once explained in an interview, many of her images stem from a set of primal scenes emanating from her own childhood, memories of sitting on the edge of her mother's bed and observing her mother prepare for nights out with her father by wearing a "merry widow" to "push up her breasts and slender her hips" before she'd slip on a glamorous, strapless dress: "Watching my mother get dressed, I used to think that this is what men want women to look like, she's transforming herself into the kind of body men want. I thought it was fascinating…. In some ways, I thought it was awful."[4]

Suffused with the intense spark produced by early forms of sexual knowledge, Ramberg's "aesthetics of uncomfortability" manage to open the space necessary to explore the ambivalent relations that many women have with the terms of their own sexuality and objectification. This space, which is often foreclosed by polite conversation, makes room for us to consider the perverse and deeply embodied sense of power that comes from being fetishized, the tricky intimacies that one sometimes forges with the

material world, and the queer forms of knowledge that certain erotic practices cannot not produce. In this, Ramberg's work confronts the reluctance to acknowledge and investigate how pleasure is often generated and experienced as a (by)product of oppression. It forces us to consider the erotics of power in more nuanced terms than most popular media outlets can seem to bear (be they on the right or the left of the political spectrum), and it demands that we account for the ways that sexual difference is erotically charged and then politically instrumentalized.

Ultimately, Ramberg's paintings extend the gendered language of seduction into the space of critique by withholding any sense of objectivity. While offering only partial perspectives, her images are nonetheless made to cohere around rather particular points of view. Works like *Probed Cinch* (1971) illustrate the value of pleasure, not just for anyone, but specifically for those whose bodies are always already inscribed with the formal language of desire—bodies marked by the seams of waist cinchers, blooming with the sting of tight, elastic thigh-highs; bodies hungry for a knowing, probing finger to slip into their naked, ambiguous spaces, teasing out the corporeal inconsistencies that don't map onto tiresome, readymade fantasies.

Notes

1 Dennis Adrian, "Christina Ramberg," in
 Christina Ramberg, A Retrospective: 1968–1988
 (Chicago: Renaissance Society, 1988), 4–14.
2 This says nothing about those women who
 also were inclined to vote for politicians
 because of their support of white supremacy,
 an ideology also rooted in patriarchy.
3 Roland Barthes, "Twenty Key Words for
 Roland Barthes," in *The Grain of the Voice*,
 trans. Linda Coverdale (Berkeley: University
 of California Press, 1985), 206.
4 Donna Seaman, *Identity Unknown:
 Rediscovering Seven American Women Artists*
 (New York: Bloomsbury, 2017), 294–295.

Osservate, leggete con me
by Frances Stark

<u>3</u>

Hey love

> *Hey you!*
> *How are you?*

I'm fine

On the couch as ever
U?
What are u doing?
> *I'm on my studio couch*
Ooooh cool!
I was hearing the song that you sent
> *What song?*
Hundred Stab
the dancehall one
> *Oh My God*
> *I can't stop listening to that I*
> *LOOOVVE it!!*
It's the 100th time that I hear it

Me too!
So glad you like it!
ehehehe
I like it so much
I await your hundred stabs
why are you waiting
tell me
You know what it means?

mmm no…
STAB WITH THE COCK!
dancehall
sacco
sesso
sacco figa
sacco
cazzo
I meant I'm waiting for YOUR
100 stabs!!
Yes but I didn't understand what did it mean
wait…
didn't you get it?
yes I did!
but I can't understand
hmmmmww
ahahahaha
1 sec
pugnalata con un coltello

yes
I knew it
 il coltello é un pene
ahhhhhhhhhhh
ahahahahahahaha
 yesssssssss
oook
ooooooook
ooooooooooooook
now I've understood
 pugnale
all clear
 "daggering" is the dance
yes, stab means cock
 no, stab means what you do with it the
 action
 thrust
 spinger
 e
 ficcare?
so I have to thrust you with the stab mine
stab?!
right?!
 haha no no no
 you have to stab me with your knife
stab is just like knife?
ah! noooooooooo
stab is the action!

111

right!?!?!
 verb = action word
so stab is the verb
the action
to stab!!!
right??
 yessss!
and the past tense of "stab" ??
stabed?
 stabbed
stabbed
ahahahahahahaha
got it!!!!!!
 we should have a comedy show
yes! yes!
Mr and Mrs Pagliacci!!!

Feminist Snap
by Sara Ahmed

SNAPFUL

When I first saw the film *A Question of Silence*,
I thought immediately that what was displayed
was a collective act of feminist snap. I turn to
this film in the final section of the chapter,
thinking with it, alongside two other feminist
films from the 1980s, *Nine to Five* and *Born in
Flames*. The word *snap* came to my mind for
what is shown in *A Question of Silence*, for what is
so powerful about this film. That word has stuck
with me since. Why this word? Let's take the full
range of potential meanings and let's treat the
word *snap* as verb, as doing something: to snap;
she snaps.

To snap can mean to make a brisk, sharp,
cracking sound; to break suddenly; to give way
abruptly under pressure or tension; to suffer a
physical or mental breakdown, especially while
under stress; to bring the jaws briskly together,
often with a clicking sound; to bite; to snatch
or grasp suddenly and with eagerness; to speak

abruptly or sharply; to move swiftly and smartly; to flash or appear to flash light; to sparkle; to open, close, or fit together with a click.

Snap is quite a sensation. To snap can be to make a sharp sound. As a feminist killjoy, I have been giving my ear to those who sound sharp. I will come back to the sounds of this sharpness; it matters. The temporality of snapping is also crucial: a snap is a sudden quick movement. The speed of snapping might be how a snap comes to be apprehended as a movement at all (the slower you move, the less a move seems like a movement).

I always think with the examples that come to mind; the sensations of being in the world with objects and others. And when I think of snap, I think of a twig. When a twig snaps, we hear the sound of it breaking. We can hear the suddenness of a break. We might assume, on the basis of what we hear, that the snap is a starting point. A snap sounds like the start of something, a transformation of something; it is how a twig might end up broken in two pieces. A snap might even seem like a violent moment; the unbecoming of something. But a snap would only be the beginning insofar as we did not notice the pressure on the twig. If pressure is an action, snap is a reaction. Pressure is hard to

notice unless you are under that pressure. Snap is only the start of something because of what we do not notice. Can we redescribe the world from the twig's point of view, that is, from the point of view of those who are under pressure?

We can begin to build a picture of how and why snap matters. I drew in part I on Marilyn Frye's recalling of the root of the meaning of oppression in *press*.[1] Bodies can be pressed into shape; or are under pressure in being shaped. We learn as well: this pressure is not always something we can witness from the outside. You might experience that pressure only when you are under it, rather like you encounter the wall when you come up against it. The weightiest of experiences are often those that are hardest to convey to those who do not share the experience. If a snap seems sharp or sudden, it might be because we do not experience the slower time of bearing or of holding up; the time in which we can bear the pressure, the time it has taken for things not to break.

If the twig was a stronger twig, if the twig was more resilient, it would take more pressure before it snapped. We can see how resilience is a technology of will, or even functions as a command: be willing to bear more; be stronger so you can bear more. We

can understand too how resilience becomes a deeply conservative technique, one especially well suited to governance; you encourage bodies to strengthen so they will not succumb to pressure; so they can keep taking it; so they can take more of it. Resilience is the requirement to take more pressure; such that the pressure can be gradually increased. Or as Robin James describes, resilience "recycles damages into more resources."[2] Damage becomes a means by which a body is asked to take it; or to acquire the strength to take more of it.

When you don't take it, when you can't take any more of it, what happens? The moment of not taking it is so often understood as losing it. When a snap is registered as the origin of violence, the one who snaps is deemed violent. She snaps. You can hear the snap in the sound of her voice. Sharp, brittle, loud; perhaps it is like the volume has suddenly been turned up, for no reason; the quietness that surrounds her ceases when she speaks, her voice cutting the atmosphere, registering as the loss of something; a nicer atmosphere, a gentler mood. And then: violence is assumed to originate with her. A feminist politics might insist on renaming actions as reactions; we need to show how her snap is not the starting point.

The killjoy gives us another handle at the very moment she seems to lose it. The feminist killjoy might herself be a snappy figure; feminists might be perceived as full of snap. Maybe there is a relation between willful and snapful. Snappiness as a quality is often defined in terms of aptitude. To be snappy is to be "apt to speak sharply or irritably." That certainly sounds like a feminist aptitude. Feminism: it has bite; she bites. We might even as feminists aim to develop this aptitude: by snapping, we acquire more snap. We aim to become snappier by snapping. This does not mean or make snappiness right or into a right. But perhaps snappiness might be required to right a wrong when a wrong requires we bear it; that we take it, or that we take more of it.

Snap: when she can't take it anymore; when she just can't take it anymore. Speaking sharply, speaking with irritation. Maybe we can hear her irritation; a voice that rises, a voice that sharpens. A voice can lose its smoothness; becoming rougher, more brittle. When her irritation speaks volumes, we might be distracted from what is irritating. Can we even distract ourselves?

Irritation is an intimacy of body and world. When I think of irritation, I think of contact dermatitis. What you come into contact with can irritate your skin. Irritation registers contact

as intrusion. The surface of your skin might become rougher as well as itchy. You might scratch your skin because it is itchy; and there might be a sense of relief, but then it becomes itchier. You know this will happen, but you can't help doing this: because those moments of relief are too precious. The quality of an experience is that of rubbing against something other than yourself, but once you are rubbed up the wrong way, it can feel like your own body is against you, even in those moments of relief. To speak from irritation is to speak of being rubbed up against the world in a certain way. Sianne Ngai describes irritation as a "minor negative affect."[3] That is such a good description. We all know that life is full of mild irritations. Perhaps irritation is a little like infection; things eventually come to a head. There is a point when it all comes out, a tipping point. There are a certain number of times you can be rubbed the wrong way, before you end up snapping. A snap might seem sudden but the suddenness is only apparent; a snap is one moment of a longer history of being affected by what you come up against.

Snap: a moment with a history.

If you are apt to be snappy, perhaps you are not happy. But perhaps this aptness is only a part of the story. Some get rubbed up the wrong way more than others; we know this. A feminist killjoy lives and works in a contact zone. She might acquire an aptitude for irritation not because of the nature of her speech or being, but because of how much she has already had to put up with. What she has to put up with becomes part of who she is. That she appears as a figure at all (remember, she is first received as an assignment by others) is often about a history of being rubbed up the wrong way. I described this in chapter 1 as "being wound up by someone who is winding you up."

We could think of feminist history as a history of snappy women. Perhaps we would be thinking of how what comes out of our own mouths is speaking this history. It might be that our tongues become snappy, speaking for us, in our struggle to speak back and to speak up. I think of *Jane Eyre*. Jane in the opening scenes of the novel, in the grim scenes of her childhood, struggles to speak back to her tyrannical aunt. Eventually Jane snaps. But she only speaks when her tongue seems to acquire a will of its

own: "I say scarcely voluntary for it seemed as if my tongue pronounced words without my will consenting to their utterance."[4] Our tongues can disobey for us; they can pronounce the words that announce a refusal to comply.

Perhaps feminists acquire willful tongues from the very act of speaking out. Perhaps we need willful tongues in order to resist being straightened out. Willful tongues: I think too of Gloria Anzaldúa's chapter, "How to Tame a Wild Tongue," from *Borderlands/La Frontera: The New Mestiza*. The chapter begins with a dramatic scene: a dentist who is cleaning the roots of her teeth says to her with "anger rising in his voice" that "we're going to have to do something about your tongue" and that he'd "never seen anything as strong and stubborn."[5] Her wayward tongue evokes the willful arm of the willful child discussed in chapter 3. Her tongue keeps pushing out the "wads of cotton, pushing back the drills, the long thin needles."[6] All the materials the dentist, concerned with health and hygiene, puts in her mouth, are pushed right out again, as if her tongue is refusing to be cleaned, as if her tongue is spreading an infection. Gloria Anzaldúa describes many attempts to tame her tongue, to make her "speak English."[7] When she tries to

tell the teacher how to pronounce her name she is heard as "talking back." To speak your own language is to become disobedient. Her tongue persists with a willful disobedience, refusing to be straightened out.

Feminism: a history of willful tongues. Feminism: that which infects a body with a desire to speak in ways other than how you have been commanded to speak. I think too of bell hooks's extraordinary text *Talking Back: Thinking Feminism, Thinking Black*. She explains how she renamed herself by adopting the name of her maternal grandmother as her pen name.[8] Elsewhere, hooks describes how her grandmother was "known for her snappy and bold tongue."[9] Here a snappy tongue is affirmed as what Black women inherit from each other; a maternal line as a snappy line. A snappy tongue gives the words for a Black woman to pen her own name.

Snap can be a genealogy, unfolding as an alternative family line, or as a feminist inheritance. I often think of snap as what I have inherited from my Pakistani aunties. My sister talks of her daughter as having Ahmed genes, and I know what she means; she means she is another point on a line of snappy women. She means: like me, like you, like our aunties, this

girl has snap. This girl has snap: maybe she too is a survival story. I think of my own family and the work that had to be done to keep things together, the work that women often did, to hold on when things are breaking up. We might, reflecting back to my discussion in chapter 7, be haunted by those breaks, even those that we did not live through ourselves. In my family's case, I think of Partition, how a country was broken up in the afterlife of colonialism; how borders became open wounds; how an infection can spread. Family stories were passed down about the trauma of Partition; a Muslim family leaving their home in Jalandhar, fleeing to Lahore, a long hard train journey, arriving, creating a new home from what had been left behind by those who, too, had fled.

We might inherit a break because it was survived. A survival can be how we are haunted by a break. When I think of this history of breaking, I think especially of my relationship to my eldest auntie, Gulzar Bano. I mentioned in the introduction how my own feminism was shaped by our many conversations. My auntie—who was most definitely snappy—did not marry. The family explanation is that this not marrying was because of Partition. A national break can be interwoven with a life story. Gulzar was

deeply involved in women's activism as well as campaigns for women's literacy and education in Pakistan. She was a poet, too. Her words were sharp like weapons. When our lives don't follow the lines provided by convention, we still have people behind us, those who offer us lifelines, without expectation of return. Becoming close to my aunt, with her passion for feminism and for what she calls in our family biography "woman power," helped me to find a different political orientation, a different way of thinking about my place in the world. In a conventional genealogy, the woman who does not have a child of her own would be an end point.

Snap, snap: the end of the line.
In a feminist and queer genealogy,
life unfolds from such points.
Snap, snap: begin again.

Notes

1 Marilyn Frye, *The Politics of Reality: Essays in Feminist Theory* (Trumansburg, NY: Crossing Press, 1983).
2 Robin James, *Resilience and Melancholy: Pop Music, Feminism, Neoliberalism* (London: Zero, 2015), 7.

3 Sianne Ngai, *Ugly Feelings* (Cambridge, MA: Harvard University Press, 2007).

4 Charlotte Brontë, *Jane Eyre* (London: Wordsworth, [1847], 1999), 21.

5 Gloria Anzaldúa, *Borderlands/La Frontera: The New Mestiza* (San Francisco: Aunt Lute, [1987], 1999), 75.

6 Ibid.

7 Ibid., 76.

8 bell hooks, *Talking Back: Thinking Feminism, Thinking Black* (Boston: South End, 1988), 9.

9 bell hooks, "Inspired Eccentricity: Sarah and Gus Oldham," in *Family: American Writers Remember Their Own*, eds. Sharon Sloan Fiffer and Steve Fiffer (New York: Vintage, 1996), 152.

Kin
by Marcela Pardo Ariza

Blanche and Stanley
by Dodie Bellamy

Claw clippings scattered across my comforter,
litter in my sheets, he kneads my tit with his
paws, he pokes my tit with his snout. She nuzzles
in my armpit, she nuzzles in my neck, he
burrows between my legs and sleeps there, he
sits between my legs with the top half of him
resting on my belly, she perches on my abdomen
and licks her asshole. She cries for vanilla ice
cream, he cries for TV dinners. He reaches out
the window and swipes at birds, he catches three
of them, dead pigeon blood and feathers all over
the living room. She leans against my left thigh
while I watch TV, she sits on my lap during my
private writing workshop, I balance student
writing on her back, she cries until I swivel in
my office chair and pick her up, I lean over her
awkwardly and try to type on the computer, she
sits on my lap when I argue, when I cry, when I
talk on the phone, she sits on my lap as I eat
breakfast, I drop oatmeal on her head. He lies at
the bottom of the bed and I rub him with my
foot, toes grazing soft fur. I roll over on my

stomach, he climbs on my ass, she joins him on the small of my back and licks his face, their bodies rumbling with satisfaction. I sit on the toilet and she squats in the litter box beside me, both of us peeing. When I stroke him his whole body quivers with pleasure and he drools on my chest. When she wants me to touch her she cries out desperately, an unpleasant cry, sharp as the squawk of a crow. When he wants me to touch him he lets out a low wail. I pull the fur tightly back from their heads and their skulls look like snake skulls. I leave a glass of water on the nightstand, and as soon as I turn my back, she has her snout in it lapping. Silent, sneaky, mono-focused, the only way to win with them is to remove what they want from sight. They're racing through the apartment trying to catch a fly, when the fly stops they freeze, waiting for just the right moment, they get so excited waiting they let out little whimpers, and I tell them that when you're trying to creep up on something whimpering is counter productive. They ignore me, crouch down, shake their fannies, pounce. The double bed is overflowing with bodies, he sleeps at the foot on my side, wails when I move him to make room for my legs—otherwise I'd have to sleep on a diagonal and then where would Kevin's legs go. She

sleeps in a ball in my arms most nights for 19 years. He snores and farts, she lets out an occasional groan, he pees in the bed while I'm sleeping, he shits in the bed when I've displeased him, both of them vomit in the bed sometimes on my pillow right next to my face, he vomits in my shoes, she eats dental floss, straw from the kitchen broom, ribbon, rose leaves, plastic bags and throws up blood-tinged foam. He shits on the couch, not every day but enough that whenever I'm not sitting on it I keep the couch covered with white plastic shower curtain liners, cheap ones I buy at Walgreen's, sometimes he pees and shits on the liners, pool of urine so yellow against the white plastic, I mop up the urine with paper towels, gather up the plastic and throw it away. If it's just shit and not too runny I'll pick it off and spray the plastic with odor remover. Sometimes I'm too lazy to remove the shower curtain liner and I sit on it, plastic bunching and crinkling beneath my ass. The apartment smells of urine and incense. Even though her food dish is full she looks up at me and cries until I either mix up the crunchies with my hand or drop in a few more pieces of food. Then she lowers her head and eats. Taupe back, creamy belly and snout, blue eyes, pale pink nose, gray and black striped tail, when I

hold her in my arms she relaxes completely, trembling with pleasure. Both of them crawl on top of me, she on my chest he on my groin, my lungs rising and falling beneath the weight of them, their lungs rising and falling in different rhythms, warmth. He butts the book I'm reading with his head, keeps butting it until I put the book down, then he scoots higher on my chest, I scratch his snout, he quivers and drools. Long black fur, white paws and belly, green eyes, pink nose with a black spot or is it black nose with a pink spot. In the morning she screams until I open the bedroom shades, then she climbs into a patch of sun and passes out. I'm lying down, he crawls on top of me, front paws on my chest, back paws on my groin, long and heavy his body presses down on me vibrating with pleasure, I put my arms around him, hard muscles beneath black fur, I feel a hit of arousal. She eats with her tail on the floor extended straight back, when I step on it she shrieks so loud I jump in the air— she never seems to get hurt, I'm in the air before that could happen. Fur fur fur fur everywhere and always the stench of urine, he kneads my lap he kneads my tit, he rubs his face against my tit and drools. She desires, she demands, she receives. When she's satisfied her body trembles. I call her Squawks, I call him Stanley Bear.

Three stories down the front gate bangs shut, they run to the door and wait for Kevin to climb the stairs. She licks my face when I'm trying to sleep, she stands on my pillow pulling my hair, he scratches me until I bleed, she pees on the bathroom floor, he gulps down his food and throws it up at my feet, shit hangs out his ass and smears on my down comforter, he's shit on the comforter so often it's limp from overwashing. Bedtime, she curls in my arms and we struggle over which direction she faces, I want her back to me, she wants claws and whiskers in my face, I fall asleep with her facing away from me, wake up with claws and whiskers in my face, her breath smells like rancid fish. If I try to wrap myself around Kevin's back, I have to leave room at the top for her to crawl between us, or she'll bat my head and cry, she will pester me and keep me awake as long as necessary to get her way, if I push her off the bed, she'll crawl back up and cry and bat, if I put them in the living room and close the door, both of them will scratch and cry, he will shit on the couch then hurl his body against the door. The two of them simultaneously lick one another's faces, it looks like they're making out, they curl beside one another and sleep, two tight balls. When I was a child I slept with a

mound of stuffed animals, I had to scoot to the edge of the twin bed to accommodate them all, my favorite was a green cotton frog my grandmother sewed and stuffed with cut-up old nylons, I used Froggy to masturbate, I'd lie on my stomach, position one of his hind legs against my clit, I clench and rub against it, the rest of Froggy bouncing on top of my butt. Kelly green frog foot flecked with dried white scum. As a girl I wished I had real animals to fondle and cuddle, and now those dreams have come true. I have the flu and she lies in bed with me for three days, barely moving, when I wrestle and toss she makes little cries of disapproval. I open the front door and they rush to greet me, running side by side, a stripe of black wedged against a strip of taupe and cream, screaming. I scoop them both up, my arms spilling over with thick vibrating fur. He rubs my tit with his head, dripping saliva on my shirt, he kneads my tit with his paws, his nails flicking out as he presses down. He eats bugs and broccoli. He digs a corncob out of the garbage, gnaws and swallows it, and almost dies. He falls out the window during the 1989 earthquake and is missing for three weeks, when he returns scared and bedraggled she hisses at him. I'm lying down, he stretches his body out on top of me,

his hind legs on my groin, his front paws touching my neck, he's so excited he drools on my chest, all 15 pounds of him pressing down on me as if he would sink through my skin and nestle in my organs, I stroke his head, he slobbers some more, I hug him, my arms full of black fur muscles bony spine, my groin lifts to meet his weight, no one's around but this is as far as I've let myself go. Warmth fish-breath drool vomit shit piss purr sting of drawn blood. In the morning when I wake up, before I open my eyes or move she's already crying and tapping my arm with her paw. When Kevin and I begin to have sex she jumps off the bed, but as soon as we've both come she jumps back up, purring loudly, we're lying on our sides arms and legs wrapped around one another, I reach over Kevin's shoulder and scratch her chin. She stands at her food bowl and screams until I get up from my desk and watch her, then she bends over and eats greedily. He gets on his hind legs, cries and bats at me until I stop writing and pick him up, he's too big for my lap, keeps shifting about, his back legs are bony against my thighs, I wrap my arms around him, hunch over and rub my chin on his head, pulling him to me tightly— she purrs when I do this, he squirms and jumps down. She climbs between my legs and curls in a

ball. He climbs between my legs and stretches straight out, claws at my crotch, his hind legs down at my feet, I jiggle my legs around him, rubbing both his sides at once. Dry chunky vomit corncob vomit clear puddle vomit rusty brown diarrhea pouring over the side of the litter box and dripping on the floor. The vet tells me to stop petting her as the purring is too loud to hear her heart. I stick needles in their backs, give him subcutaneous fluids twice a day for a month, give her subcutaneous fluids twice a week then every other day for a year, I pry open their jaws and throw pills down their throats, I gob flea killer on the backs of their necks, squirt liquids down their throats that makes them squirm and gag, I mix baby food with water and squirt it down his throat, when he's too weak to sit up I feed him baby shrimp, one by one from my palm, every day I walk to Safeway to get him fresh shrimp. I open capsules and mix the contents in cat food which they sniff, walk away from and screech for something untainted. I rub thyroid medicine in her ears twice a day for three years, if I rub a certain spot her hind legs twitches uncontrollably. Thin, flexible hairy triangle, inside her ear less fur and pink. I decide when it's time for them to die. His lungs empty their final load with two deep sighs, she slumps

over silently, eyes staring. As I walk through the apartment afterwards, soft strands of fur dust the corners, invisible bits of dander cling to the hair on my forearms, wedge beneath my nails, enter my eyes, my mouth, my nostrils.

Interior
by Thomas Clerc

Translated from the French
by Jeffrey Zuckerman

Center
However portable and transportable my
computer may be, it still spends the vast majority
of its time at home. I only export it on (working)
vacations. Contrary to its design, I treat this
object as an immobile piece of furniture: it
holds court over the office. I've come to realize
that writing happens only at the center: it's a
centered, central activity that necessitates 2
equally sized spaces on each side. All the rest
falls into place around it.

Stolen Soul
The 1 other place in my apartment suitable for
my computer is the sanctuary where I store it
when I'm away. This spot has to remain secret,
so I won't say anything more about it; I don't
care how many real-life apples thieves make off
with, but if 1 of them were to filch my Apple,

that would be like stealing my soul—really, I ought to praise my burglar for having been more interested in my watch than in a machine that clearly struck him as beneath his notice…Or maybe he just didn't see it because it was sitting in plain sight on my desk?

Suprematist Composition: White on White
Pressing a sheet of A4 paper onto the screen.

Parent Company
"Home is the most important place in the world," declared IKEA; but Apple retorted that, these days, people live online. With a distinct advantage over libraries and other such enclosed spaces, computers lead to a hyperspace. The object itself is perfectly solid if I open its lid; but within its few inches is contained an entire, intangible universe (which isn't for public display). Computers hold so much in so little space that they almost seem boundless. The computer overflows with realms; maybe it's everything an animal isn't.

Wireless
My computer is, alas, wired. 1st to the printer, which in turn binds it to paper; then, on its right side, to the power outlet, which keeps

this beast well nourished. Its battery barely lasts 2 hours, so it has to be fed, like an elderly shut-in, through a plug with an oblong end (which resembles, in miniature, the entryway's ceiling light), which draws energy from 1 white square block, often quite hot, that connects to the computer via 1 long cord. I know that the newest computer models do away with nearly all wires, and I'm delighted because I hate those things. Wi-Fi has already weaned us off the main yellow cable. When, at last, every cord is cut, the future really will be now. And as if it could hear me, my power cord, drawn by a fundamental force, slips across the desk and lands on the floor like a dead snake.

Tumbles

Thus does my mute apartment succumb every so often to a fleeting animism; a tumult over which I have 0 control wrecks every object. A bulb will simply pop, who knows why (though, when I was a child, I myself was why: I once poured water over a bulb I worried was overheating: the glass's abrupt shattering terrified me, and that image of bodies maimed and ruined by my mistakes turned me away from medical practice altogether). The mysterious tumble of a book, a bag, or a bit of food creates some magic in

the heart of the everyday. There's no rhyme or reason to such occurrences. And yet, if I listen carefully, I can hear my belongings' political demands: they protest the close quarters I keep them in, want to reclaim a bare minimum of space in this city where there's practically none. The uncooked spaghetti on the floor becomes a giant game of pick-up sticks.

Sacred Left

The desk comprises 4 drawers on each side for a total of 8, in perfect symmetry, though I'd hoped to reserve the left side for what I consider sacred, and the right for what I consider profane, thereby establishing a sort of monument to opposition.

The left side is the empire of the archive. The uppermost drawer, the most accessible 1, since I can open it without my left hand (the 1 I write with) exerting any effort, is for work currently under way. (The presence of my "more present" hand and the "currency" of my current work have a relationship I couldn't necessarily explain, but which I simply know must be the case; clearly 1's body is always in the present tense.) I also keep my cell phone charger in this drawer. 1 could be forgiven for considering this dainty black appendix to be so purely an

accessory in our era that it's just about worthless, seeing as they're given away for free with every new phone. And while it might call to mind the age-old tradition of knotting a string around your finger to help remind you of something, the many knots that keep cropping up in my charger's cord only serve to draw attention to how thin and shoddy it is, its reach being reduced with each successive use—if my cell phone rings while it's charging, the cord isn't long enough for me to maneuver, and I have to adopt an awkward, almost painful pose that amounts to me slumping toward the ground and twisting my neck toward the phone, stuck in that position so I don't yank the cord out of its socket. It would be better to kneel, I think, although that would make such conversations still more bizarre, even if I, being opposed to videophones, were the only 1 to know it, so the best solution is to set the charging phone on a low shelf and to let the cord hang slack.

In his poetry, Francis Ponge liked to give such mundane objects a voice; sometimes, though, I think he might have done better to let them keep their mouths shut.

USB

I also keep my 2 USB thumb drives here, although "keep" might not be the right word: they're so small that they always and immediately get lost in the depths of the drawer (45 cm deep, 12 cm high); the moment I want to grab 1, I'm forced to pick up various folders and rummage blindly through the undergrowth. I don't know what USB stands for (although I have a feeling the S is for "security"); Fear and Prudence drive me to always keep duplicates of such items— objects whose loss would be felt far more keenly than those of greater proportions: alongside the small 6 cm Emtec with its transparent cap revealing its metal connector, I have a 2nd drive that's 8 cm, brand name PNY, in gray aluminum with a translucent pink window that displays the beautiful French word *attaché*, befitting this thing that keeps our lives on a leash. These 2 drives contain all the texts I'm currently working on, about 100 of them total. They are as small as their potential is grand!

Technology: Gender-Neutral

As I focus my attention on these drives, I find myself mentally associating them with both clitorises and penises. Their size, their smallness, their power all remind me of the combined

delicacy and strength of female and male genitalia, and so I wonder if technology's gender isn't perhaps simply Neutral, making it equally desirable to our entire species.

Genesis of *1 Apartment*
In the 2nd left-hand drawer, which I can still reach without moving, is another set of colorful folders containing multiple texts, organized by genre and title, such as *1 Apartment*, the 1st draft of the book you're currently reading, which constitutes its genesis, and which I will preserve for future researchers. Although I have a particular aversion to the genetic criticism that literary theory, completely overwhelmed by the formalism of the '70s, saw fit to make the foundation of a new religion, exhuming masses of ur-texts and alternate drafts, I can't in good conscience rebuff the gravedigger's impulse, and I'll even facilitate their task by saying here that the flat, preliminary title above was quickly replaced by the 1 that wound up being final. After all, *Voyage Around My Room* was already taken, and moreover wouldn't be accurate in terms of the surface area covered by my book; as for *My Big Apartment*, well, I'm not too keen on the ironic approach.

Past Clercs

Opening the 3rd drawer calls for 1 sideways shift and 1 slight hunch downward: as we tend to distance ourselves spatially from what's become distant temporally, so this drawer contains older folders, already gone a bit yellow, that I barely ever look at: aborted or abandoned or abrogated projects that feel as though they hail from another era and only make me shudder in this 1. Then, in the final drawer, at the bottom of the desk, you'll find the various notebooks comprising my diary from the distant epoch ('85-'90) when I wrote by hand. Although I've typed up the majority of those texts on my computer, I still keep these artifacts, not so much out of fetishism as out of a simple conviction that paper is at less risk of destruction than the contents of a screen: there's no such thing as a paper virus, after all. Down here I've planted the seeds of a literary genre that draws its paradoxical prestige from being situated below most human beings: minor, infra-aesthetic, insignificant, bordering on the pathetic, in which the sublime is confounded with the trivial, in which literature gets into bed with daily life, and whose sole concern ought really to be the question of how best to verbalize a mass of facts that only the act of writing

could ever dignify. I'm unlikely to publish my diary: Cocteau believed that publishing a diary during 1's life ran the risk of revealing all the diarist's inadvertent falsehoods, which is why I'm convinced that doing so would be an error in the eyes of truth, and as much as I might admire those who do go public with their private records, I know I don't have such courage—which is exactly why I admire them. And on top of that, there are no great revelations to be found in my diary; the life that I've set down there could be of interest only to those who consider life to be a great revelation in itself.

Profane Right
The left hemisphere of my desk contains manufactured items, the right hemisphere the tools for such manufacture. And this very nicely satisfies my penchant for keeping realms distinct, hewing to the beautiful, symmetrical classifications of the classical era, as well as to my own propensity for militant inversion: as I'm left-handed, the sinister is my proper domain, and thus, the contrary to society's natural assumption as to which side is sacred, the domain of creation, in this case it's—rightfully—*gauche*. Literature isn't innately up-right: it's imperfect, fragile, sometimes even a failure,

and it finds success only in its own clumsiness and deception. The right side of this piece of furniture, therefore, is the 1 I've chosen to devote to the material and blameless domain of the secretary.

Paper Tiger

The 1st drawer from the top, the identical twin of that on the right, is devoted to paper of all sorts: sheets, cards, envelopes, etc. The 3rd drawer contains about 100 worksheets, 21 x 29.7 cm sheets folded in half, crosswise, on which I typically summarize the many books I'd have liked to write. The particular fold of these homely sheets allows me, by imitating the form of a book, to have a 4-sided sheet and not merely a 2-sided 1: what I lose in length I gain in depth, and this little paper ruse spares me from any confusion with the other, unfolded 21 x 29.7 sheets as I stack them and grab them without looking.

Price per Square Sheet

I pick up 1 blank sheet. I turn it in different directions. I could put some black on this white, to give it some value, but I can also fetch a decent sum just by setting it on the floor: if we measure its worth according to the cost

of 1 Parisian square meter (€8,000), we get its price: €498.96. Its virtual cost is in 2 dimensions, whereas real wealth, of course is in 3. What if the decrease in intellectual value were a direct function of the exorbitant price of surfaces? Then who would be able to hold a salon these days?

Otherworld Order

Any harried reader certainly will have overlooked how, in the terrible succession of descriptions I've in inflicted upon her or him, I've jumbled the order of the drawers, going without any warning from the 1st to the 3rd, when it would have been more correct to list the contents of the 2nd drawer in between—but textual order and real order are 2 different things. My reason isn't strictly a literary 1 (even though, notwithstanding how it may appear, this book isn't meant to be a simple snapshot of my apartment, but really my apartment in written form), but rather lies in the violation of the principle I stated further up, when I decreed the division of prerogatives between the creative left and the performative right. As if this binary scission of space hadn't done justice to these objects, I haven't entirely succeeded at avoiding any confusion between the sacred and the profane.

Performance Drawer

The accordion folder that resides in this 2nd drawer is pudgy; its flaps break free of its black straps and its bulk hampers my attempts to get the drawer open; I yank anyway, denting the corner of the sleeve titled *Performances*, which I've willfully destroyed. When life annoys, irritates, or outright hurts me (I do have a delicate sensibility), I start in on this compensatory tic: opening and shutting the drawer several times, quicker and quicker, in order to make the damage even worse. By carrying out this conscious cruelty, I project my frustration onto the 1 expanding folder dedicated to my performances, an activity to which I devote a good portion of my writing time, and have done since 2007. The word *performance* suits this willfully repetitive gesture, which subjects my folder to exactly the same sort of activity that it serves to archive. And I'd like to end this digression with a theoretical problem that's always bothered me: Does a performance require an audience? If I apply my definition of "performance" to this act of repeatedly opening and shutting a drawer, in order to execute the (minor) depredation of an object, is this really a performance, or is it so to only my eyes? X claims that brushing his teeth alone in his

bathroom can be called a performance; for
him, I guess, it certainly can, but to the degree
that there's no audience there to witness it or
appreciate it, I would say that it only becomes a
performance at the moment when it's addressed
to someone else, via some form of mediation.
As such, my own performance—"The 2nd
Drawer"—finds its raison d'être in its being
recorded here, on pages 201-202 of *Interior*.

Profaner Still

In the most profane and profound drawer, the
last, I've stuffed all my digital debris: computer
manuals, ISP phone numbers, plugs, cords,
external hard drives, and other accessories. I try
to minimize to the maximum [*sic*] the problem
of opening it, like so many other problems
I'd rather keep thoroughly buried: and so this
choice of the bottommost drawer is propitiatory,
because I dread those "technical issues" a lack
of proper education has left me perpetually
unprepared to deal with.

Cleaning

The only item in this reserve that I attach any
value to is the universal screen cleaner, 1 small
spray bottle protected by 1 small cap, which I
use to get rid of dust, bits of grime, fingerprints,

and other signs of general wear and tear that assault the creamy purity of the iBook G4 that Stéphane Mallarmé, way ahead of his time, called "the white disquiet of our canvas." I have 0 idea whether this cleaner is right for my Mac's chassis, but I use it anyway, on the assumption that I can't go far wrong simply spraying a product made in Germany on the surface of another from Japan. To finish up the operation, I use a former table napkin. Reusing and repurposing objects fills so many chapters in the history of art; this particular repurposing might be modest, even a bit degrading, but that's the fate of cloth, this material made from next to nothing, born in splendor but ending in misery, and touching us with its similarity to our own destiny. In this same vein, to wax my shoes, I use old T-shirts or old mismatched socks, and to clean the apartment I put on old jogging pants that are as inelegant as the pantaloons that venerable dukes who had fallen on hard times and become pensioners wore with illusory opulence before accepting the rags of Welfare. The fantasy of pushing snobbery to the point of wearing brand-name clothes or expensive fabrics for menial housecleaning work gives me a peculiar delight in which I can still recognize my bent for subservience, humiliation,

degeneration. (And to think that these base lips of mine once touched the napkin now consecrated to dusting off my sacred screen!)

Center Drawer

I open the center drawer, which is large and deep as a pensive belly. Among various articles for schooltime use (1 ruler; some tape; scissors; a pocket calculator that the Banque populaire gave me in hopes, I suppose, of becoming even more popular; 1 pencil sharpener; some thumbtacks and staples; etc.), all of them in a box that formerly held Turkish delights bought in Istanbul, the drawer holds 3 additional objects, talismanic in nature: my planner, my address book, and my map of Paris. My planner will take its place, at the year's end, alongside the other black planners in the freestanding bookshelves (→ *infra*); other people may use iPhones, but I've stayed faithful to paper, which has never failed me. My address book isn't, like my cell phone, errant; rather, it gathers all the people I know together into 1 space, along with their mailing addresses (how quaint!). As for my Paris map, it crushes Google by giving me an overview that isn't so much local as global: I've never had to help so many tourists on the street as when the good old paper map was supplanted

by electronics (and it's quite clear they'd all rather have recourse to some random photocopy than be forced to interact with the likes of me!).

In any case, GPS, the death knell of spatial memory, is something I've managed to keep in abeyance with my map, with my love for my territory. For my part, I'll leave my reader with a small floor plan of my home—though if our species' memories of the spaces we inhabit go on blurring into nothingness, then maybe, 1 day, I'll also include an appendix featuring numerous photos of this apartment (for a small additional fee).

Story of the Eye
by Georges Bataille

Translated from the French
by Joachim Neugroschal

6. Simone

One of the most peaceful eras of my life was
the period following Simone's minor accident,
which only left her ill. Whenever her mother
came, I would step into the bathroom. Usually,
I took advantage of these moments to piss or
even bathe; the first time the woman tried to
enter, she was immediately stopped by her
daughter: "Don't go in," she said, "there's a
naked man in there."

Each time, however, the mother was
dismissed before long, and I would take my
place again in a chair next to the sickbed.
I smoked cigarettes, went through newspapers,
and if there were any items about crime or
violence, I would read them aloud. From
time to time, I would carry a feverish Simone
to the bathroom to help her pee, and then I
would carefully wash her on the bidet. She was

extremely weak and naturally I never stroked her seriously; but nevertheless, she soon delighted in having me throw eggs into the toilet bowl, hard-boiled eggs, which sank, and shells sucked out in various degrees to obtain varying levels of immersion. She would sit for a long time, gazing at the eggs. Then she would settle on the toilet to view them under her cunt between the parted thighs; and finally, she would have me flush the bowl.

Another game was to crack a fresh egg on the edge of the bidet and empty it under her: sometimes she would piss on it, sometimes she made me strip naked and swallow the raw egg from the bottom of the bidet. She did promise that as soon as she was well again, she would do the same for me and also for Marcelle.

At that time, we imagined Marcelle, with her dress tucked up, but her body covered and her feet shod: we would put her in a bath tub half filled with fresh eggs, and she would pee while crushing them. Simone also daydreamed about my holding Marcelle, this time with nothing on but her garter belt and stockings, her cunt aloft, her legs bent, and her head down; Simone herself, in a bathrobe drenched in hot water and thus clinging to her body but exposing her bosom, would then get up on a

white enameled chair with a cork seat. I would arouse her breasts from a distance by lifting the tips on the heated barrel of a long service revolver that had been loaded and just fired (first of all, this would shake us up, and secondly, it would give the barrel a pungent smell of powder). At the same time, she would pour a jar of dazzling white *crème fraîche* on Marcelle's gray anus, and she would also urinate freely in her robe or, if the robe were open, on Marcelle's back or head, while I could piss on Marcelle from the other side (I would certainly piss on her breasts). Furthermore, Marcelle herself could fully inundate me if she liked, for while I held her up, her thighs would be gripping my neck. And she could also stick my cock in her mouth, and what not.

It was after such dreams that Simone would ask me to bed her down on blankets by the toilet, and she would rest her head on the rim of the bowl and fix her wide eyes on the white eggs. I myself settled comfortably next to her so that our cheeks and temples might touch. We were calmed by the long contemplation. The gulping gurgle of the flushing water always amused Simone, making her forget her obsession and ultimately restoring her high spirits.

At last, one day at six, when the oblique sunshine was directly lighting the bathroom, a

half sucked egg was suddenly invaded by the water, and after filling up with a bizarre noise, it was shipwrecked before our very eyes. This incident was so extraordinarily meaningful to Simone that her body tautened and she had a long climax, virtually drinking my left eye between her lips. Then, without leaving the eye, which was sucked as obstinately as a breast, she sat down, wrenching my head toward her on the seat, and she pissed noisily on the bobbing eggs with total vigor and satisfaction.

By then she could be regarded as cured, and she demonstrated her joy by speaking to me at length about various intimate things, whereas ordinarily she never spoke about herself or me. Smiling, she admitted that an instant ago, she had felt a strong urge to relieve herself completely, but had held back for the sake of greater pleasure. Truly, the urge bloated her belly and particularly made her cunt swell up like a ripe fruit; and when I passed my hand under the sheets and her cunt gripped it firm and tight, she remarked that she was still in the same state and that it was inordinately pleasant. Upon my asking what the word urinate reminded her of, she replied: terminate, the eyes, with a razor, something red, the sun. And egg? A calf's eye, because of the color of the

head (the calf's head) and also because the white of the egg was the white of the eye, and the yolk the eyeball. The eye, she said, was egg-shaped. She asked me to promise that when we could go outdoors, I would fling eggs into the sunny air and break them with shots from my gun, and when I replied that it was out of the question, she talked on and on, trying to reason me into it. She played gaily with words, speaking about breaking eggs, and then breaking eyes, and her arguments became more and more unreasonable.

She added that, for her, the smell of the ass was the smell of powder, a jet of urine a "gunshot seen as a light"; each of her buttocks was a peeled hard-boiled egg. We agreed to send for hot soft-boiled eggs without shells, for the toilet, and she promised that when she now sat on the seat, she would ease herself fully on those eggs. Her cunt was still in my hand and in the state she had described; and after her promise, a storm began brewing little by little in my innermost depth—I was reflecting more and more.

It is fair to say that the room of a bedridden invalid is just the right place for gradually rediscovering childhood lewdness. I gently sucked Simone's breast while waiting for the soft-boiled eggs, and she ran her fingers through my hair. Her mother was the one who brought us the

eggs, but I didn't even turn around, I assumed it was a maid, and I kept on sucking the breast contentedly. Nor was I ultimately disturbed when I recognized the voice, but since she remained and I couldn't forego even one instant of my pleasure, I thought of pulling down my trousers as for a call of nature, not ostentatiously, but merely hoping she would leave and delighted at going beyond all limits. When she finally decided to walk out and vainly ponder over her dismay elsewhere, the night was already gathering, and we switched on the lamp in the bathroom. Simone settled on the toilet, and we each ate one of the hot eggs with salt. With the three that were left, I softly caressed her body, gliding them between her buttocks and thighs, then I slowly dropped them into the water one by one. Finally, after viewing them for a while, immersed, white, and still hot (this was the first time she was seeing them peeled, that is naked, drowned under her beautiful cunt), Simone continued the immersion with a plopping noise akin to that of the soft-boiled eggs.

But I ought to say that nothing of the sort ever happened between us again, and, with one exception, no further eggs ever came up in our conversations; nevertheless, if we chanced to notice one or more, we could not help reddening

when our eyes met in a silent and murky interrogation.

At any rate, it will be shown by the end of this tale, that this interrogation was not to remain without an answer indefinitely, and above all, that this unexpected answer is necessary for measuring the immensity of the void that yawned before us, without our knowledge, during our singular entertainments with the eggs.

Kathy Acker's Clothes
by Kaucyila Brooke

162

165

169

170

171

172

173

174

176

177

179

181

182

183

Hold Me Now
by Glen Helfand

Like many people, I have a hard time imagining
my parents having sex. They didn't seem to
touch each other, at least not in front of anyone.
For me, their bodies were abstractions. They
started a family in the early 1960s, but they were
a bit too old to be hippies. So the idea of being
nude in the California sun wasn't something
they embraced. Once, and only once, when I
was a small child, my father took me into the
shower with him. I was as tall as his knees. I still
recall how he looked so imposing, his adult body
solid and hairy—it frightened me, though my
body probably resembles his now. I never saw
my mother naked, when she was young or old. I
don't exactly know what her breasts looked like,
her body in general, but I can imagine.

She wasn't short, but she was thin. Her
weight, she'd sometimes say, hovered around
115 when healthy. There was a curious lack
of dimension to her frame—she seemed full
head on, but flattened out from the side. When
she sat on the couch, her thighs, encased in
polyester slacks, seemed to pool like pancake

batter hitting the skillet. Perhaps she had no muscle holding her flesh to the bone; women of her generation didn't exercise as people do now. She did sometimes wade in the pool, in a one-piece. For a time, she favored a fashion that had a little ruffled skirt below the hips and graphic, Marimekko knock-off flowers on the fabric, a distraction from the varicose veins and that sense of horizontal spread. A raffia hat would shield her from UV rays. She spent her youth in Los Angeles but couldn't swim. She'd cling to the shaded side of the pool and kick her legs. Sometimes I'd swim around her. I never really tried to understand her resistance to swimming—she said she didn't want to get her hair wet—nor did I ever consider I could gently hold her in the pool, to help her navigate the water. Perhaps her sense of physical precarity amplified her fragile, untouchable aura.

My mother wasn't a hugger, but how could she not have needed one now and then? In that adolescent zone of not wanting to imagine her marital relations, neither did I ever consider her need to be held. She did a good job of keeping that at bay, presenting a contained self who moved into private places and perhaps severe headaches or stomach upset when she needed to be alone. But maybe those were moments when

she needed to be tended to. The bedroom door was closed, we let her have her space.

During the final stretch of living in her own house, before the Alzheimer's took full hold, my father would tell me about cuddling her. He'd never before said anything about spooning, about the warmth of her body, and how much he appreciated it (though sometimes with the surprise of a soiled adult diaper). I got the impression that they may not have engaged in this form of intimacy at all until this point. Her condition softened him, made him more caring. Their needs were more apparent, no longer hidden.

I saw more of my mother's body than I ever had while she was on her deathbed—only there was so much less of her. At this point, she was becoming an abstraction, a person withered beyond recognition and personhood. Her eyes were glued shut as she lay there, her frame sinking into the narrow mattress, disappearing. I stood a few feet away, watching, hearing her rasp. She seemed more breakable than when she was cognizant, walking upright. The idea of touching her seemed dangerous, as though her bones would shatter and crumble, sharp edges turn to dust. The rhythm of her breath was erratic. Her legs poked out from the woven

blanket, and I tentatively touched the skin on her calves, surprised by its coolness—her body temperature had dropped in the extremities.

Of course, her last breath was what I was waiting for. I rationalized not holding her out of respect, but in truth it was fear. Scooping her up for a hug didn't even cross my mind because getting close to her filled me, I'm ashamed to admit, with horror. She was a pile of bones, a stranger whom I barely recognized. Yet, in this moment, we both needed the comforting embrace of the one we were meant to be to each other: a mother cradling her child at a time of crisis, and vice versa. I think we both always feared the expression of our needs—it was a lineage.

It had been years, it seemed, since there was some quality to her experience. Deeper into her illness, she cycled between emotions, with no awareness that tears and cries for her "mommy" would be followed by childlike wonder, and back again to sobs. She'd be fed soft, green purees of vegetables or pale potato, spooned between her cracked lips. Caregivers would give her drugs to stimulate appetite. This was a form of life support. Hunger is as much a metaphor as a necessity. They were keeping her eating something so she would not lose the impulse fully.

The staff seemed to find my mother sweet. This surprised me, as I had trouble seeing beyond her reserve—it was as if she held back her sweetness at home; there, her gentleness seemed more like opaque reserve. I was glad they could feed, bathe, and soothe her as I couldn't. I didn't know how. They could lift her up in their arms, provide a physical contact that I could not offer myself during my infrequent visits. For me to hold her would be to cradle illness and death, and I was petrified. To hold her hands, with dirt under her fingernails, and to breathe in her moldering cave halitosis would make it clear that she was human and in need of care. My fear felt deeply humiliating, perhaps as much as she might have felt knowing I'd seen her like this, so raw and undefended, in a pure, self-contained state of vulnerability.

I wanted to bolt but fought the urge, for fear that the staff would see me stay for such a cowardly short period of time. So, I sat in a chair a few feet away, a safe distance from her hospital bed, and tried to summon words of caring that I uttered in whispers. We hadn't had a conversation in years, at least not one that made any sense. Her babbling was in a language I didn't understand, and didn't try to learn. "I love you," I said self-consciously. Her labored

breaths continued, her eyes still glued shut with mucus. Was that a twitch of acknowledgement in her cheek muscles? Maybe she heard that, I couldn't be sure.

In previous months, my sister had tried to coax words with fancy Italian cookies from an upscale market, but I couldn't go that route. It seemed futile, and the disappointment in her lack of coherent response to this treat seemed to devastate my sibling. Being there with mom could feel pointless. Between visits, the awareness of her existence was a concept, a floating obligation.

A cold, hard character: Me. Not being there for my mother was an example of this. Friends might say there was nothing I could do. Be kind to yourself, they'd advise. "Give yourself a hug."

I wondered about people who treated ailing parents with reverence and adoration, and I considered those who approached their ailing relatives like lepers, avoiding the infirm altogether. My proximity was in the middle. Did I cause pain to her by not being there more regularly, by not embracing her and being more compassionate? Was I giving her some payback for her inability to hold me? I could reconcile it this way: she got no love from her own parents, critical and resentful immigrants, and didn't

know how to teach it her children. So, there I was, facing deficit, collapsing under the faulty congenital foundations.

It wasn't until after she died that I, at my sister's request, had some home movies digitized. One was a reel from our parents' 1959 honeymoon, where she looked lovely and svelte, cavorting in the surf, playfully acknowledging her fear of heights as she peered down from the balcony of their high-rise hotel suite in Acapulco. My father was leaner than I recall him, handsome in his way. As each operated the camera, there was never a shot of them together, no evidence of afterglow.

I see myself in both of them, yet am surprised by the happiness they express in that footage, demeanors I never witnessed in real life. The house in the suburbs, the strains of a family, must have taken that away.

On that final visit, I could only imagine myself kissing my mother's forehead, the feel of her skull that seemed so visible beneath the taut, paper-thin skin. But I couldn't actually bring myself to get that close.

Why?
by Bob Flanagan

Because it feels good;
because it gives me an erection;
because it makes me come;
because I'm sick;
because there was so much sickness;
because I say fuck the sickness;
because I like the attention;
because I was alone alot;
because I was different;
because kids beat me up on the way to school;
because I was humiliated by nuns;
because of Christ and the crucifixion;
because of Porky Pig in bondage, force-fed by
some sinister creep in a black cape;
because of stories of children hung by their
wrists, burned on the stove, scalded in tubs;
because of Mutiny on the Bounty;
because of cowboys and Indians;
because of Houdini;
because of my cousin Cliff;
because of the forts we built and the things we
did inside them;

because of my genes;

because of my parents;

because of doctors and nurses;

because they tied me to the crib so I wouldn't hurt myself;

because I had time to think;

because I had time to hold my penis;

because I had awful stomach aches and holding my penis made it feel better;

because I'm a Catholic;

because I still love Lent, and I still love my penis, and in spite of it all I have no guilt;

because my parents said be what you want to be, and this is what I want to be;

because I'm nothing but a big baby and I want to stay that way, and I want a mommy forever, even a mean one, especially a mean one;

because of all the fairy tale witches and the wicked step mother, and the step sisters, and how sexy Cinderella was, smudged with soot, doomed to a life of servitude;

because of Hansel, locked in a witch's cage until he was fat enough to eat;

because of "O" and how desperately I wanted to be her;

because of my dreams;

because of the games we played;

because I have an active imagination;

because my mother bought me tinker toys;
because hardware stores give me hard-ons;
because of hammers, nails, clothespins, wood,
padlocks, pullies, eyebolts, thumbtacks, staple-
guns, sewing needles, wooden spoons, fishing
tackle, chains, metal rulers, rubber tubing,
spatulas, rope, twine, C-clamps, S-hooks, razor
blades, scissors, tweezers, knives, push pins, two-
by-fours, ping-pong tables, alligator clips, duct
tape, broom sticks, bar-b-que skewers, bungie
cords, saw horses, soldering irons;
because of tool sheds;
because of garages;
because of basements;
because of dungeons;
because of The Pit and The Pendulum;
because of the Inquisition;
because of the rack;
because of the cross;
because of the Addams Family playroom;
because of Morticia Addams and her black dress
with its octopus legs;
because of motherhood;
because of Amazons;
because of the Goddess;
because of the Moon;
because it's in my nature;
because it's against nature;

because it's nasty;
because it's fun;
because it flies in the face of all that's normal,
whatever that is;
because I'm not normal;
because I used to think that I was part of some
vast experiment and that there was this implant
in my penis that made me do these things and
allowed them, whoever they were, to monitor
my activities;
because I had to take my clothes off and lie
inside this giant plastic bag so the doctors could
collect my sweat;
because once upon a time I had such a high fever
my parents had to strip me naked and wrap me
in sheets to stop the convulsions;
because my parents loved me even more when I
was suffering;
because I was born into a world of suffering;
because surrender is sweet;
because I'm attracted to it;
because I'm addicted to it;
because endorphins in the brain are like a
natural kind of heroin;
because I learned to take my medicine;
because I was a big boy for taking it;
because I can take it like a man;
because, as someone once said, he's got more

balls than I do;
because it is an act of courage;
because it does take guts;
because I'm proud of it;
because I can't climb mountains;
because I'm terrible at sports;
because no pain, no gain;
because spare the rod and spoil the child;

BECAUSE YOU ALWAYS HURT THE ONE
YOU LOVE.

Selections from Tammy Rae Carland's Record Collection

BARTH

O BE VULGAR,
ROFITABLE

H'S NEWEST
ST RELEASE

LAF

PAR'

!!!!

HATTIE No

OF THE

'Y

!

"the funniest won

MOMS MABL

dan brewstein

n in the world"

Y ONSTAGE

CHESS LP 1447

BDS 5048 STEREO

the next to last joan rivers album

Buddah Records is a Subsidiary of Viewlex, Inc. Printed in U.S.A.

PHYLLIS
DILLER
LAUGHS

V-15028

VERVE RECORDS

HI-FI
Living Sound Fidelity

LSP-3879 **STEREO**

Carol Burnett sings

O IT ALL
Y
Y GIRL
IME
LAUGHING (from the Columbia Picture "Enter Laughing")
JOSITY
E'S NO BUSINESS LIKE SHOW BUSINESS
T TILL THE SUN SHINES, NELLIE
WHAT DID I HAVE
THAT I DON'T HAVE?

And that's
the truth

Lily Tomlin

STEREO PD 5023
2391 028

LIVE AT LAST

ATLANTIC
SD 2-9000
2 RECORD SET

FONTAINE (Edite

SURFER CHICK

PROD
Associat

F
WHOOPI GOLDBERG ORIGI
Prome

oldberg

...3 RPM

...e One

...or Radio) **3:05**

...e Two

...ted for Radio) **3:45**

...W MIKE NICHOLS
...er: Barry Josephson
...Biff Dawes
...Geffen album
...ADWAY SHOW RECORDING (GHS 24065)
...opy. Not For Sale.

...FFEN
...RDS.

GILDA
RADNER
LIVE
FROM
NEW YORK

with
- Dan Aykroyd
- John Belushi
- Chevy Chase
- Jane Curtin
- Garrett Morris
- Laraine Newman
- Gilda Radner

A NETFLIX ORIGINAL COMEDY SPECIAL

Hannah G

Nanette

adsby

NETFLIX

The Carrier Bag of Fiction
by Ursula K. Le Guin

In the temperate and tropical regions where it appears that hominids evolved into human beings, the principal food of the species was vegetable. Sixty-five to eighty percent of what human beings ate in those regions in Paleolithic, Neolithic, and prehistoric times was gathered; only in the extreme Arctic was meat the staple food. The mammoth hunters spectacularly occupy the cave wall and the mind, but what we actually did to stay alive and fat was gather seeds, roots, sprouts, shoots, leaves, nuts, berries, fruits, and grains, adding bugs and mollusks and netting or snaring birds, fish, rats, rabbits, and other tuskless small fry to up the protein. And we didn't even work hard at it—much less hard than peasants slaving in somebody else's field after agriculture was invented, much less hard than paid workers since civilization was invented. The average prehistoric person could make a nice living in about a fifteen-hour work week.

Fifteen hours a week for subsistence leaves a lot of time for other things. So much time that

maybe the restless ones who didn't have a baby around to enliven their life, or skill in making or cooking or singing, or very interesting thoughts to think, decided to slope off and hunt mammoths. The skillful hunters then would come staggering back with a load of meat, a lot of ivory, and a story. It wasn't the meat that made the difference. It was the story.

It is hard to tell a really gripping tale of how I wrested a wild-oat seed from its husk, and then another, and then another, and then another, and then another, and then I scratched my gnat bites, and Ool said something funny, and we went to the creek and got a drink and watched newts for a while, and then I found another patch of oats. No, it does not compare, it cannot compete with how I thrust my spear deep into the titanic hairy flank white Oob, impaled on one huge sweeping tusk, writhed screaming, and blood spouted everywhere in crimson torrents, and Boob was crushed to jelly when the mammoth fell on him as I shot my unerring arrow straight through eye to brain.

That story not only has Action, it has a Hero. Heroes are powerful. Before you know it, the men and women in the wild-oat patch and their kids and the skills of the makers and the thoughts of the thoughtful and the songs of the

singers are all part of it, have all been pressed into service in the tale of the Hero. But it isn't their story. It's his.

When she was planning the book that ended up as *Three Guineas*, Virginia Woolf wrote a heading in her notebook, "Glossary"; she had thought of reinventing English according to a new plan, in order to tell a different story. One of the entries in this glossary is *heroism*, defined as "botulism." And *hero*, in Woolf's dictionary, is "bottle." The hero as bottle, a stringent reevaluation. I now propose the bottle as hero.

Not just the bottle of gin or wine, but bottle in its older sense of container in general, a thing that holds something else.

If you haven't got something to put it in, food will escape you—even something as uncombative and unresourceful as an oat. You put as many as you can into your stomach while they are handy, that being the primary container; but what about tomorrow morning when you wake up and it's cold and raining and wouldn't it be good to have just a few handfuls of oats to chew on and give little Oom to make her shut up, but how do you get more than one stomachful and one handful home? So you get up and go to the damned soggy oat patch in the rain, and wouldn't it be a good thing if you had

something to put Baby Oo Oo in so that you could pick the oats with both hands? A leaf a gourd a shell a net a bag a sling a sack a bottle a pot a box a container. A holder. A recipient.

The first cultural device was probably a recipient …. Many theorizers feel that the earliest cultural inventions must have been a container to hold gathered products and some kind of sling or net carrier.

So says Elizabeth Fisher in *Women's Creation*.[1] But no, this cannot be. Where is that wonderful, big, long, hard thing, a bone, I believe, that the Ape Man first bashed somebody with in the movie and then, grunting with ecstasy at having achieved the first proper murder, flung up into the sky, and whirling there it became a space ship thrusting its way into the cosmos to fertilize it and produce at the end of the movie a lovely fetus, a boy of course, drifting around the Milky Way without (oddly enough) any womb, any matrix at all? I don't know. I don't even care. I'm not telling that story. We've heard it, we've all heard all about all the sticks spears and swords, the things to bash and poke and hit with, the long, hard things, but we have not heard about the thing to put things in, the container for the thing contained. That is a new story. That is news.

And yet old. Before—once you think about it, surely long before—the weapon, a late, luxurious, superfluous tool; long before the useful knife and ax; right along with the indispensable whacker, grinder, and digger—for what's the use of digging up a lot of potatoes if you have nothing to lug ones you can't eat home in—with or before the tool that forces energy outward, we made the tool that brings energy home. It makes sense to me. I am an adherent of what Fisher calls the Carrier Bag Theory of human evolution.

This theory not only explains large areas of theoretical obscurity and avoids large areas of theoretical nonsense (inhabited largely by tigers, foxes, other highly territorial mammals); it also grounds me, personally, in human culture in a way I never felt grounded before. So long as culture was explained as originating from and elaborating upon the use of long, hard objects for sticking, bashing, and killing, I never thought that I had, or wanted, any particular share in it. ("What Freud mistook for her lack of civilization is woman's lack of *loyalty* to civilization," Lillian Smith observed.) The society, the civilization they were talking about, these theoreticians, was evidently theirs; they owned it, they liked it; they were human, fully human, bashing, sticking, thrusting, killing. Wanting to be human too, I

sought for evidence that I was; but if that's what it took, to make a weapon and kill with it, then evidently I was either extremely defective as a human being, or not human at all.

That's right, they said. What you are is a woman. Possibly not human at all, certainly defective. Now be quiet while we go on telling the Story of the Ascent of Man the Hero.

Go on, say I, wandering off towards the wild oats, with Oo Oo in the sling and little Oom carrying the basket. You just go on telling how the mammoth fell on Boob and how Cain fell on Abel and how the bomb fell on Nagasaki and how the burning jelly fell on the villagers and how the missiles will fall on the Evil Empire, and all the other steps in the Ascent of Man.

If it is a human thing to do to put something you want, because it's useful, edible, or beautiful, into a bag, or a basket, or a bit of rolled bark or leaf, or a net woven of your own hair, or what have you, and then take it home with you, home being another, larger kind of pouch or bag, a container for people, and then later on you take it out and eat it or share it or store it up for winter in a solider container or put it in the medicine bundle or the shrine or the museum, the holy place, the area that contains what is sacred, and then next day you probably do much

the same again—if to do that is human, if that's what it takes, then I am a human being after all. Fully, freely, gladly, for the first time.

Not, let it be said at once, an unaggressive or uncombative human being. I am an aging, angry woman laying mightily about me with my handbag, fighting hoodlums off. However I don't, nor does anybody else, consider myself heroic for doing so. It's just one of those damned things you have to do in order to be able to go on gathering wild oats and telling stories.

It is the story that makes the difference. It is the story that hid my humanity from me, the story the mammoth hunters told about bashing, thrusting, raping, killing, about the Hero. The wonderful, poisonous story of Botulism. The killer story.

It sometimes seems that that story is approaching its end. Lest there be no more telling of stories at all, some of us out here in the wild oats, amid the alien corn, think we'd better start telling another one, which maybe people can go on with when the old one's finished. Maybe. The trouble is, we've all let ourselves become part of the killer story, and so we may get finished along with it. Hence it is with a certain feeling of urgency that I seek the nature, subject, words of the other story, the untold one, the life story.

It's unfamiliar, it doesn't come easily, thoughtlessly to the lips as the killer story does; but still, "untold" was an exaggeration. People have been telling the life story for ages, in all sorts of words and ways. Myths of creation and transformation, trickster stories, folktales, jokes, novels…

The novel is a fundamentally unheroic kind of story. Of course the Hero has frequently taken it over, that being his imperial nature and uncontrollable impulse, to take everything over and run it while making stern decrees and laws to control his uncontrollable impulse to kill it. So the Hero has decreed through his mouthpieces the Lawgivers, first, that the proper shape of the narrative is that of the arrow or spear, starting *here* and going straight *there* and THOK! hitting its mark (which drops dead); second, that the central concern of narrative, including the novel, is conflict; and third, that the story isn't any good if he isn't in it.

I differ with all of this. I would go so far as to say that the natural, proper, fitting shape of the novel might be that of a sack, a bag. A book holds words. Words hold things. They bear meanings. A novel is a medicine bundle, holding things in a particular, powerful relation to one another and to us.

231

One relationship among elements in the novel may well be that of conflict, but the reduction of narrative to conflict is absurd. (I have read a how-to-write manual that said, "A story should be seen as a battle," and went on about strategies, attacks, victory, etc.) Conflict, competition, stress, struggle, etc., within the narrative conceived as carrier bag/belly/box/house/medicine bundle, may be seen as necessary elements of a whole which itself cannot be characterized either as conflict or as harmony, since its purpose is neither resolution nor stasis but continuing process.

Finally, it's clear that the Hero does not look well in this bag. He needs a stage or a pedestal or a pinnacle. You put him in a bag and he looks like a rabbit, like a potato.

That is why I like novels: instead of heroes they have people in them.

So, when I came to write science-fiction novels, I came lugging this great heavy sack of stuff, my carrier bag full of wimps and klutzes, and tiny grains of things smaller than a mustard seed, and intricately woven nets which when laboriously unknotted are seen to contain one blue pebble, an imperturbably functioning chronometer telling the time on another world, and a mouse's skull; full of beginnings

without ends, of initiations, of losses, of transformations and translations, and far more tricks than conflicts, far fewer triumphs than snares and delusions; full of space ships that get stuck, missions that fail, and people who don't understand. I said it was hard to make a gripping tale of how we wrested the wild oats from their husks, I didn't say it was impossible. Who ever said writing a novel was easy?

If science fiction is the mythology of modern technology, then its myth is tragic. "Technology," or "modern science" (using the words as they are usually used, in an unexamined shorthand standing for the "hard" sciences and high technology founded upon continuous economic growth), is a heroic undertaking, Herculean, Promethean, conceived as triumph, hence ultimately as tragedy. The fiction embodying this myth will be, and has been, triumphant (Man conquers earth, space, aliens, death, the future, etc.) and tragic (apocalypse, holocaust, then or now).

If, however, one avoids the linear, progressive, Time's-(killing)-arrow mode of the Techno-Heroic, and redefines technology and science as primarily cultural carrier bag rather than weapon of domination, one pleasant side effect is that science fiction can be seen

as a far less rigid, narrow field, not necessarily Promethean or apocalyptic at all, and in fact less a mythological genre than a realistic one.

It is a strange realism, but it is a strange reality.

Science fiction properly conceived, like all serious fiction, however funny, is a way of trying to describe what is in fact going on, what people actually do and feel, how people relate to everything else in this vast sack, this belly of the universe, this womb of things to be and tomb of things that were, this unending story. In it, as in all fiction, there is room enough to keep even Man where he belongs, in his place in the scheme of things; there is time enough to gather plenty of wild oats and sow them too, and sing to little Oom, and listen to Ool's joke, and watch newts, and still the story isn't over. Still there are seeds to be gathered, and room in the bag of stars.

Note

1 Elizabeth Fisher, *Women's Creation* (New York: McGraw-Hill, 1975).

Uses of the Erotic, the Erotic as Power
by Audre Lorde

There are many kinds of power, used and unused, acknowledged or otherwise. The erotic is a resource within each of us that lies in a deeply female and spiritual plane, firmly rooted in the power of our unexpressed or unrecognized feeling. In order to perpetuate itself, every oppression must corrupt or distort those various sources of power within the culture of the oppressed that can provide energy for change. For women, this has meant a suppression of the erotic as a considered source of power and information within our lives.

We have been taught to suspect this resource, vilified, abused, and devalued within Western society. On the one hand, the superficially erotic has been encouraged as a sign of female inferiority; on the other hand, women have been made to suffer and to feel both contemptible and suspect by virtue of its existence.

It is a short step from there to the false belief that only by the suppression of the erotic within

our lives and consciousness can women be truly strong. But that strength is illusory, for it is fashioned within the context of male models of power.

As women, we have come to distrust that power which rises from our deepest and non-rational knowledge. We have been warned against it all our lives by the male world, which values this depth of feeling enough to keep women around in order to exercise it in the service of men, but which fears this same depth too much to examine the possibility of it within themselves. So women are maintained at a distant/inferior position to be psychically milked, much the same way ants maintain colonies of aphids to provide a life giving substance for their masters.

But the erotic offers a well of replenishing and provocative force to the woman who does not fear its revelation, nor succumb to the belief that sensation is enough.

The erotic has often been misnamed by men and used against women. It has been made into the confused, the trivial, the psychotic, the plasticised sensation. For this reason, we have often turned away from the exploration and consideration of the erotic as a source of power and information, confusing it with its opposite,

the pornographic. But pornography is a direct denial of the power of the erotic, for it represents the suppression of true feeling. Pornography emphasizes sensation without feeling.

The erotic is a measure between the beginnings of our sense of self and the chaos of our strongest feelings. It is an internal sense of satisfaction to which, once we have experienced it, we know we can aspire. For having experienced the fullness of this depth of feeling and recognizing its power, in honor and self-respect we can require no less of ourselves.

It is never easy to demand the most from ourselves, from our lives, from our work. To go beyond the encouraged mediocrity of our society is to encourage excellence. But giving in to the fear of feeling and working to capacity is a luxury only the unintentional can afford, and the unintentional are those who do not wish to guide their own destinies.

This internal requirement toward excellence which we learn from the erotic must not be misconstrued as demanding the impossible from ourselves nor from others. Such a demand incapacitates everyone in the process. For the erotic is not a question only of what we do; it is a question of how acutely and fully we can feel in the doing. Once we know the extent to which we

are capable of feeling that sense of satisfaction and completion, we can then observe which of our various life endeavors brings us closest to that fullness.

The aim of each thing which we do is to make our lives and the lives of our children richer and more possible. Within the celebration of the erotic in all our endeavors, my work becomes a conscious decision, a longed for bed which I enter gratefully and from which I rise up empowered.

Of course, women so empowered are dangerous. So we are taught to separate the erotic demand from most vital areas of our lives other than sex. And the lack of concern for the erotic root and satisfactions of our work is felt in our disaffection from so much of what we do. For instance, how often do we truly love our work even at its most difficult?

The principal horror of any system which defines the good in terms of profit rather than in terms of human need, or which defines human need to the exclusion of the psychic and emotional components of that need, the principal horror of such a system is that it robs our work of its erotic value, its erotic power and life appeal and fulfillment. Such a system reduces work to a travesty of necessities, a duty

by which we earn bread or oblivion for ourselves and those we love. But this is tantamount to blinding a painter and then telling her to improve her work, and to enjoy the act of painting. It is not only next to impossible, it is also profoundly cruel.

As women, we need to examine the ways in which our world can be truly different. I am speaking here of the necessity for reassessing the quality of all the aspects of our lives and of our work, and of how we move toward and through them.

The very word erotic comes from the Greek word eros, the personification of love in all its aspects born of Chaos, and personifying creative power and harmony. When I speak of the erotic, then, I speak of it as an assertion of the lifeforce of women; of that creative energy empowered, the knowledge and use of which we are now reclaiming in our language, our history, our dancing, our loving, our work, our lives.

There are frequent attempts to equate pornography and eroticism, two diametrically opposed uses of the sexual. Because of these attempts, it has become fashionable to separate the spiritual (psychic and emotional) from the political, to see them as contradictory or antithetical. "What do you mean, a poetic

revolutionary, a meditating gunrunner?" In the same way, we have attempted to separate the spiritual and the erotic, thereby reducing the spiritual to a world of flattened affect, a world of the ascetic who aspires to feel nothing. But nothing is farther from the truth. For the ascetic position is one of the highest fear, the gravest immobility. The severe abstinence of the ascetic becomes the ruling obsession. And it is one not of self-discipline but of self-abnegation.

The dichotomy between the spiritual and the political is also false, resulting from an incomplete attention to our erotic knowledge. For the bridge which connects them is formed by the erotic, the sensual, those physical, emotional, and psychic expressions of what is deepest and strongest and richest within each of us, being shared: the passions of love, in its deepest meanings.

Beyond the superficial, the considered phrase, "It feels right to me," acknowledges the strength of the erotic into a true knowledge, for what that means is the first and most powerful guiding light toward any understanding. And understanding is a handmaiden which can only wait upon, or clarify, that knowledge, deeply born. The erotic is the nurturer or nursemaid of all our deepest knowledge.

The erotic functions for me in several ways, and the first is in providing the power which comes from sharing deeply any pursuit with another person. The sharing of joy, whether physical, emotional, psychic, or intellectual, forms a bridge between the sharers which can be the basis for understanding much of what is not shared between them, and lessens the threat of their difference.

Another important way in which the erotic connection functions is the open and fearless underlining of my capacity for joy. In the way my body stretches to music and opens into response, hearkening to its deepest rhythms, so every level upon which I sense also opens to the erotically satisfying experience, whether it is dancing, building a bookcase, writing a poem, examining an idea.

That self-connection shared is a measure of the joy which I know myself to be capable of feeling, a reminder of my capacity for feeling. And that deep and irreplaceable knowledge of my capacity for joy comes to demand from all of my life that it be lived within the knowledge that such satisfaction is possible, and does not have to be called marriage, nor god, nor an afterlife.

This is one reason why the erotic is so feared, and so often relegated to the bedroom alone,

when it is recognized at all. For once we begin
to feel deeply all the aspects of our lives, we
begin to demand from ourselves and from
our life-pursuits that they feel in accordance
with that joy which we know ourselves to be
capable of. Our erotic knowledge empowers us,
becomes a lens through which we scrutinize all
aspects of our existence, forcing us to evaluate
those aspects honestly in terms of their relative
meaning within our lives. And this is a grave
responsibility, projected from within each of us,
not to settle for the convenient, the shoddy, the
conventionally expected, nor the merely safe.

During World War II, we bought sealed
plastic packets of white, uncolored margarine,
with a tiny, intense pellet of yellow coloring
perched like a topaz just inside the clear skin of
the bag. We would leave the margarine out for
a while to soften, and then we would pinch the
little pellet to break it inside the bag, releasing
the rich yellowness into the soft pale mass of
margarine. Then taking it carefully between
our fingers, we would knead it gently back and
forth, over and over, until the color had spread
throughout the whole pound bag of margarine,
thoroughly coloring it.

I find the erotic such a kernel within myself.
When released from its intense and constrained

pellet, it flows through and colors my life with a kind of energy that heightens and sensitizes and strengthens all my experience.

We have been raised to fear the yes within ourselves, our deepest cravings. But, once recognised, those which do not enhance our future lose their power and can be altered. The fear of our desires keeps them suspect and indiscriminately powerful, for to suppress any truth is to give it strength beyond endurance. The fear that we cannot grow beyond whatever distortions we may find within ourselves keeps us docile and loyal and obedient, externally defined, and leads us to accept many facets of our oppression as women.

When we live outside ourselves, and by that I mean on external directives only rather than from our internal knowledge and needs, when we live away from those erotic guides from within ourselves, then our lives are limited by external and alien forms, and we conform to the needs of a structure that is not based on human need, let alone an individual's. But when we begin to live from within outward, in touch with the power of the erotic within ourselves, and allowing that power to inform and illuminate our actions upon the world around us, then we begin to be responsible to ourselves in the

deepest sense. For as we begin to recognize our deepest feelings, we begin to give up, of necessity, being satisfied with suffering and self-negation, and with the numbness which so often seems like their only alternative in our society. Our acts against oppression become integral with self, motivated and empowered from within.

In touch with the erotic, I become less willing to accept powerlessness, or those other supplied states of being which are not native to me, such as resignation, despair, self-effacement, depression, self-denial.

And yes, there is a hierarchy. There is a difference between painting a back fence and writing a poem, but only one of quantity. And there is, for me, no difference between writing a good poem and moving into sunlight against the body of a woman I love.

This brings me to the last consideration of the erotic. To share the power of each other's feelings is different from using another's feelings as we would use a kleenex. When we look the other way from our experience, erotic or otherwise, we use rather than share the feelings of those others who participate in the experience with us. And use without consent of the used is abuse.

In order to be utilized, our erotic feelings must be recognized. The need for sharing

deep feeling is a human need. But within the European-American tradition, this need is satisfied by certain proscribed erotic comings together. These occasions are almost always characterized by a simultaneous looking away, a pretense of calling them something else, whether a religion, a fit, mob violence, or even playing doctor. And this misnaming of the need and the deed give rise to that distortion which results in pornography and obscenity, the abuse of feeling.

When we look away from the importance of the erotic in the development and sustenance of our power, or when we look away from ourselves as we satisfy our erotic needs in concert with others, we use each other as objects of satisfaction rather than share our joy in the satisfying, rather than make connection with our similarities and our differences. To refuse to be conscious of what we are feeling at any time, however comfortable that might seem, is to deny a large part of the experience, and to allow ourselves to be reduced to the pornographic, the abused, and the absurd.

The erotic cannot be felt secondhand. As a Black lesbian feminist, I have a particular feeling, knowledge, and understanding for those sisters with whom I have danced hard, played, or

even fought. This deep participation has often been the forerunner for joint concerted actions not possible before.

But this erotic charge is not easily shared by women who continue to operate under an exclusively European-American male tradition. I know it was not available to me when I was trying to adapt my consciousness to this mode of living and sensation.

Only now, I find more and more women, identified women brave enough to risk sharing the erotic's electrical charge without having to look away, and without distorting the enormously powerful and creative nature of that exchange. Recognizing the power of the erotic within our lives can give us the energy to pursue genuine change within our world, rather than merely settling for a shift of characters in the same weary drama.

For not only do we touch our most profoundly creative source, but we do that which is female and self-affirming in the face of a racist, patriarchal, and anti-erotic society.

Rosemarie Trockel
interviewed by Jutta Koether

Jutta Koether: *We have reached a pluralistic state of art, where everything is allowed. Countless currents and trends exist side by side. Should an artist not even more urgently set out the formal boundaries for his work?*

Rosemarie Trockel: It isn't important to set out limits for yourself. What is more important is to make clear the ideas you are dealing with. I work within an integrated structure. Now and then I produce pictures, sculptures, and objects, and I consider it important (in order to make my position clear) always to return to the main lines I very often depart from. I don't believe that an artist should give explanations, we mustn't understand art that way. However, things must be set within a totality which doesn't leave any doubts about their direction. Frankness does not imply interchangeability.

JK: *What demands do you make on your work?*

RT: That I don't get lost in frivolity, and that my assertions—every stroke is one—should be understood.

JK: *Do you consider an attitude of opposition to be a component of art?*

RT: Of course. But facing every artist is the paradoxical task of achieving beauty without gloss.

JK: *What is the relation between you and the "models" of modern art as far as the question of artistic conduct is concerned. I refer, for instance, to Duchamp's* Negation of Art as Life-Work *or, at the opposite pole to Joseph Beuys's* Enlargement of the Conception of Art in Social Sculpture.

RT: Unfortunately, there are too many cases that have shown that the historical models were only used and consumed to bolster the theories of younger artists. For me and in my position as a woman it is more difficult, as women have historically, always been left out. And that's why I'm interested not only in the history of the victor, but also in that of the weaker party. The masks, for example, consist not only of what they say or intend to say, but also of what they exclude. They have absence as subject.

249

Perverse or Artistic
by Julia Kristeva

Translated from the French
by Leon S. Roudiez

The abject is related to perversion. The sense of abjection that I experience is anchored in the superego. The abject is perverse because it neither gives up nor assumes a prohibition, a rule, or a law; but turns them aside, misleads, corrupts; uses them, takes advantage of them, the better to deny them. It kills in the name of life—a progressive despot; it lives at the behest of death—an operator in genetic experimentations; it curbs the other's suffering for its own profit—a cynic (and a psychoanalyst); it establishes narcissistic power while pretending to reveal the abyss—an artist who practices his art as a "business." Corruption is its most common, most obvious appearance. That is the socialized appearance of the abject.

An unshakable adherence to Prohibition and Law is necessary if that perverse interspace of abjection is to be hemmed in and thrust aside.

Religion, Morality, Law. Obviously always arbitrary, more or less; unfailingly oppressive, rather more than less; laboriously prevailing, more and more so.

Contemporary literature does not take their place. Rather, it seems to be written out of the untenable aspects of perverse or superego positions. It acknowledges the impossibility of Religion, Morality, and Law—their power play, their necessary and absurd seeming. Like perversion, it takes advantage of them, gets round them, and makes sport of them. Nevertheless, it maintains a distance where the abject is concerned. The writer, fascinated by the abject, imagines its logic, projects himself into it, introjects it, and as a consequence perverts language—style and content. But on the other hand, as the sense of abjection is both the abject's judge and accomplice, this is also true of the literature that confronts it. One might thus say that with such a literature there takes place a crossing over of the dichotomous categories of Pure and Impure, Prohibition and Sin, Morality and Immorality.

For the subject firmly settled in its superego, a writing of this sort is necessarily implicated in the interspace that characterizes perversion; and for that reason, it gives rises in turn to abjection.

And yet, such texts call for a softening of the superego. Writing them implies an ability to imagine the abject, that is, to see oneself in its place and to thrust it aside only by means of the displacements of verbal play. It is only after his death, eventually, that the writer of abjection will escape his condition of waste, reject, abject. Then, he will either sink into oblivion or attain the rank of incommensurate ideal. Death would thus be the chief curator of our imaginary museum; it would protect us in the last resort from the abjection that contemporary literature claims to expend while uttering it. Such a protection, which gives its quietus to abjection, but also perhaps to the bothersome, incandescent stake of the literary phenomenon itself, which, raised to the status of the sacred, is severed from its specificity. Death thus keeps house in our contemporary universe. By purifying (us from) literature, it establishes our secular religion.

"#AIMNOSTALGIA"
by Juliana Huxtable

I WAS ALWAYS TURNED ON BY PRIVACY. LIKE MANY, I EXPLORED MY ADOLESCENT SEXUAL CURIOSITY IN AIM CHAT ROOMS, CAT-FISHING FOR THE REPRESSED BABY-BOOMERS WHO NEVER ENJOYED SUCH A LUXURY IN THEIR OWN YOUTH. MY FIRST BLOWJOB AND THE FIRST TIME I WAS FUCKED WERE WITH MADDOG32, A USER WHOM I IMAGINED TO BE A LATE 20S BROWN-HAIRED MAN OF MY OLD NAVY DREAMS AND WHO, WHEN NOT "AWAY" CONSUMED MY TIME AND ENERGY IN A 200 PIXEL BOX WITH RAINBOW SPECTRUM TEXT. BIT BY BIT I VOLUNTARILY GAVE UP THE PHYSICAL (MEET AT A PARTY) AND SEMI-PHYSICAL (BUY CLOTHES AT A MALL) FOR THE PROTECTIVE VEIL OF 0'S AND 1'S THAT GUARDED THE SCRUTINY-FREE REIGN OF DESIRE AND PRIDE THAT I HAD DEVELOPED. SOMETIMES I GO BACK TO MY ABANDONED EMAIL ACCOUNTS AND LOOK AT THE ASS PICS I WOULD SEND. I JUST WANTED TO LOOK AT THE BODIES OF THOSE WHO MIGHT OTHERWISE NEVER BE COMFORTABLE ENOUGH TO SHOW OR SHARE.

IT'S A BITTERSWEET SORT OF REMINISCENCE, ONE THAT'S NOW TAINTED WITH THE COLLECTIVE OBSESSION OVER CHILD ACTOR'S DICK PICS. AS THE OMNIPRESENT PROBE OF GOVERNMENTAL OBSESSION IS EXPOSED, SO TOO IS THE VAGINA OF A BASKETBALL WIFE WHO IS PROVING OR ATTEMPTING TO PROVE THAT *HERS* IS REAL. THE SAME NET THAT CAST ITS CHARACTERS AND SCRIPTS ON AND BY MEANS OF MY REFLECTION GAVE UP THE SECRETS OF HOW I SUFFOCATED MYSELF IN A FETISH. EVERY 18-32 YEAR OLD IN THE DEVELOPED WORLD NOW KNOWS THE TRUTH OF THE TRANSSEXUAL EMPIRE ARMING PSEUDO-WOMEN WITH VAGINAS IN SERVICE OF THE CURIOUS MEN BAITED AND PUBLICLY BROUGHT TO JUSTICE ON *TO CATCH A PREDATOR*.

BRITNEY SPEARS WAS LOCKED IN HER BATHROOM CRYING BALD AND MY EMAIL ACCOUNT HAS BEEN HACKED BY MY FATHER, WHO ONLY THEN DISCOVERED THAT I USED HIS COMPUTER TO TALK TO OUR NEIGHBOR'S CLOSETED FTM DAUGHTER FOR HOURS OF C2C HEDONISM. IF HE DIDN'T FIND IT, SOMEONE IN THE RANK-AND-FILE OF BLOATED BUREAUCRATS FEVERISHLY LOOKING FOR DETAILS OF THE GIRL HE SAW ON THE GPS DATING APP WOULD HAVE. PHOTOS ON

GAWKER, IPHONE SNAPS OF INCONSPICUOUS SUBWAY RIDERS SEEM TO VERIFY THE ALL AMERICAN PHILOSOPHY OF "I HAVE NOTHING TO HIDE, AND THEREFORE HAVE NOTHING TO BE AFRAID OF" THAT EVERY PUBLIC NEWS DEBATE RESTS ITS CASE ON.

LESS THAT ANYONE HAS FEWER THINGS TO HIDE THAN PERHAPS WE'VE GOT EACH OTHER IN A CATCH 22. IF I WAS SAVY ENOUGH, I'D PURCHASE MY SUBSCRIPTION TO MY PORN AND HOOKUP SITES WITH BITCOIN, WHICH MIMICS GOLD AND IN ITS DIGITAL ALCHEMY, OFFER-ING FOUND MONEY TO THE MULTITUDE OF PEER TO PEER ANONY-MOUS USERS, MAKING MATERIAL (WELL, SORT OF) THE DREAM I HAD THAT VALUE, IDENTITY AND POWER HAS ONLY AS MUCH AGENCY AS WE BELIEVE OR CHOOSE TO BELIEVE IT DOES (RE: CATFISH).

MAYBE WHEN I GET MY SURGERY, ASSUMING THAT I DO AT SOME POINT, I WILL FINALLY FEEL LIKE THE WOMAN I AM INSIDE BY POSTING PHOTOS OF THE $32,000 PUSSY GOD GAVE A TALENTED SURGEON IN THAILAND THE ABILITY TO SCULPT FROM A SCARRED BODY DIS-TORTED BY YEARS OF DYSPHORIA. IN REALITY, THE PHOTOS WOULD BE NO MORE A TESTAMENT TO THE TRUTH OF THE MATTER THAN TO THE IMPLOSION OF THE LINK BETWEEN TEMPORALITY, USER-NAME-IN-PHOTO, AND TRUTH.

THE ENTIRE VILLAGE OF STEUBENVILLE TURNED ITS EYES ELSEWHERE AS THE TWEETS, PHOTOS, VIDEOS AND STATUSES OF TEEN RAPISTS DID ALL BUT FORCE US TO WITNESS THE TRANSGRESSION AGAIN IN TIME TRAVEL. BUT YOUTH IS ALWAYS AN EXCUSE, AT LEAST INSOFAR AS WE COTNINUE TO HOLD ON TO THE FANTASY OF IT AS JUSTIFICA-TION FOR CRIMINAL ACTS THAT MAYBE MOST OF US WOULD RATHER DISAPPEAR INTO THE CRUEL AND UNDER-EXPOSED WORLD OF YOUTH.

I WORRY THAT MY OLD ACCOUNTS ARE STILL THERE ONLINE, WAIT-ING TO SURFACE AT AN INCONVENIENT MOMENT SHOULD I EVER BE IN A MORE POLITE PUBLIC EYE ... AS IF THAT WOULD BE NECESSARY.

THE iMOBILE, EVER-PRESENT SHARE-TUMBLE-TWEET-POST-REBLOG REGIME SEEMS TO HAVE SUCCESSFULLY KILLED THE FLESH OF IT ALL, THE BODY BEHIND THE IMAGE.

WHAT HAPPENED TO THAT PRECIOUS EPOCH WHEN MEN WERE MEN AND WOMEN WERE WOMEN? TO THE DRAFT THAT TIED THE POPULATION AT LARGE TO THE GOVERNMENT'S WILL AS AN ARM OR PHENOMENON OF/AS *ITS* MATERIALITY.

I'M NOT SURPRISED AFTER THE SCREENCAP. IT'S MADE EVERYTHING PERMANENT, EPHEMERALITY A MERE ILLUSION. I'VE TRIED ROMANTICIZING ACTUAL IRL CONVOS AS CONTRABAND, BUT I KNOW THAT'S A SILLY CONCEPT GIVEN THE CAPABILITIES OF SHAZAM SOFTWARE. BUT THE TINGLE STILL FEELS GOOD WHEN MY LOVER SPEAKS RIGHT AGAINST MY EAR AND THEIR VOCAL VIBRATIONS TICKLE MY SPINE.

TO THE DEGREE THAT I'VE ALWAYS BEEN AS NOSEY AS I WAS CURIOUS, THE CULT OF PERSONALITY THAT BIRTHED AMERICAN EXCEPTIONALISM HAS TURNED ON A POPULATION IN WHICH WE ARE EACH OTHERS PERSONALITIES. EACH OF US AN ICON IN OUR OWN RIGHT WITH LEGACIES AND MYTHOLOGIES—AND DIRTY MATERIAL—LINGERING IN BINARY CODES. I NOW FIND MYSELF FIGHTING AN INCESSANT NEED TO UNVEIL AND TO REVEAL THE FALLIBILITY OF THE INFALLIBLE POPULATION OF COWARDLY WITCH-HUNTERS.

THE AMERICAN DREAM THAT SUSTAINED THE FANTASY OF MOBILITY IS HAVING ITS OLD ACCOUNTS AND DRUNKEN TEXTS BROUGHT TO THE PUBLIC'S ATTENTION. THE UNDERBELLY OF THE PRIVACY IT PROUDLY PROTECTED HAS EMERGED AS CRAIGSLIST, PORN, THE RIGHT TO KILL TRESPASSERS. WE STAND NAKED IN GLASS BOXES WITNESSING EACH OTHER SCRUTINIZE FAT, BONES, BODILY FLUIDS, POCKETED DISHES, AND PHOTOS ON FAULTY HARD-DRIVES.

IF REAL POWER BEGINS WHERE SECRECY BEGINS, THEN, AS WE FRANTICALLY SEARCH FOR DICK PICS OF JUSTIN BIEBER OR OUR NEXT DOOR NEIGHBOR WHO WE'RE CONVINCED POSTED THE FACELESS CRAIGSLIST AD SEEKING AN ASIAN BOTTOM, WE'RE SEDUCED INTO A BEAUTIFUL DISTRACTION IN WHICH WE ARE CONVINCED, BY VIRTUE OF OUR VICTORIOUS TOPPLING OF THE LIVES OF OTHERS, THAT WE INDEED HAVE NOTHING TO HIDE.

I'VE PERSONALLY NEVER BELIEVED AS MUCH AS I STILL HAVE TO GET MY TUCK RIGHT WHEN I PISS OR SHIT. YESTERDAY I TRIED TO JUSTIFY MY DISBELIEF AND COULDN'T GET PAST THE 4 HOURS IT TOOK ME TO UNDO EVERY "AGREE TO TERMS" I'D COMPLIED WITHIN THE LAST 4 IPHONE APPS I INSTALLED.

ITS A DISGUSTING HYPERTROPHY THAT'S KILLED MY CURIOSITY, SEXUAL DRIVE AND DESIRE FOR SEX REASSIGNMENT IN ONE BLOW.

#AIMNOSTALGIA

The Visits
by Michele Carlson

I. <u>Background Information</u>

Case Number: 81-20/KSY ██████████

According to the information from the police
station, ████████████

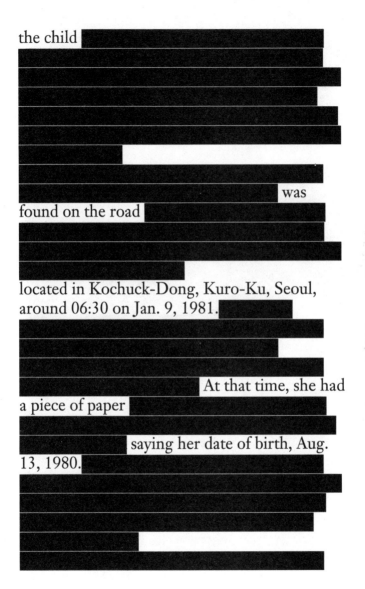

the child ▮▮▮▮▮▮▮▮▮▮▮▮▮▮▮▮▮▮▮
▮▮▮▮▮▮▮▮▮▮▮▮▮▮▮▮▮▮▮▮▮▮▮▮▮
▮▮▮▮▮▮▮▮▮▮▮▮▮▮▮▮▮▮▮▮▮▮▮▮▮
▮▮▮▮▮▮▮▮▮▮▮▮▮▮▮▮▮▮▮▮▮▮▮▮▮
▮▮▮▮▮▮▮▮▮▮▮▮▮▮▮▮▮▮▮▮▮▮▮▮▮
▮▮▮▮▮▮▮▮▮▮▮▮ was
found on the road ▮▮▮▮▮▮▮▮▮▮
▮▮▮▮▮▮▮▮▮▮▮▮▮▮▮▮▮▮▮▮▮▮▮▮▮
▮▮▮▮▮▮▮▮▮▮▮▮▮
located in Kochuck-Dong, Kuro-Ku, Seoul,
around 06:30 on Jan. 9, 1981. ▮▮▮▮▮
▮▮▮▮▮▮▮▮▮▮▮▮▮▮▮▮▮▮▮▮▮▮▮▮▮
▮▮▮▮▮▮▮▮▮▮▮▮▮▮▮▮▮▮▮▮▮▮▮▮▮
▮▮▮▮▮▮▮▮▮▮▮ At that time, she had
a piece of paper ▮▮▮▮▮▮▮▮▮▮▮▮
▮▮▮▮▮▮▮▮▮ saying her date of birth, Aug.
13, 1980. ▮▮▮▮▮▮▮▮▮▮▮▮▮▮▮▮
▮▮▮▮▮▮▮▮▮▮▮▮▮▮▮▮▮▮▮▮▮▮▮▮▮
▮▮▮▮▮▮▮▮▮▮▮▮▮▮▮▮▮▮▮▮▮▮▮▮▮
▮▮▮▮▮▮▮▮▮▮▮▮▮▮▮▮▮▮▮▮▮▮▮▮▮

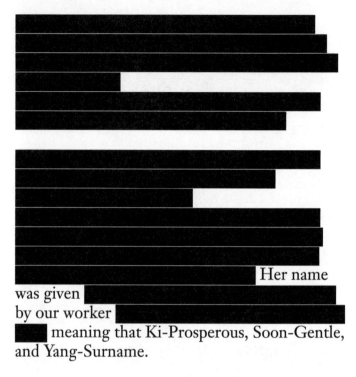

Her name was given by our worker ▮ meaning that Ki-Prosperous, Soon-Gentle, and Yang-Surname.

I have been to prison sixty-seven times, but this story doesn't begin in prison. It begins with a woman none of us knows and two kids in the system—Seoul in winter.

On my laptop screen, a thick comforter of snow elegantly levels the mismatched, rough edges of the city, where white dusts brown, tiled rooftops and the silence of winter trims stoic

temples. *Looks goddamn cold*, at least according to my Google image search of "January in Seoul, Korea." I scroll through hundreds of photos on my computer—they become one big blur, a digital whiteout. Scroll, scan, search.

> *Babe, I love you so, I want you to know,*
> *I love you so.*
> *I'm gonna miss your love,*
> *the minute you walk out that door.*
> *Please don't go. Don't go. Don't go.*[1]

KC's falsetto pleads into my ear buds. So, I click on the YouTube video that peeks from behind my search window for "what happened in 1980" and see an emotional Harry Wayne Casey. Eyes closed, fists clenched, starched white collars violently piercing the air—this must be what they mean by "from the soul" [blue-eyed soul].

> *Please don't go.*

I search—online only, refreshing searches for the date or place I was abandoned on a road, in January, when I was six months old at 6:30 a.m., and goddamn cold, I imagine.

Even five years ago, the Internet couldn't find search results for "Kochuck-Dong, Kuro-Ku, Seoul," where I was found. For twenty-five years, I thought this was an intersection and would try to find the street, or avenue, or drive. But it's actually an administrative neighborhood within a district, not two specific streets. Today, Google can correct the romanization to Gocheok-dong, Guro-gu—my lazy American tongue can barely make out the difference. The more detailed the Internet becomes, the more I disappear.

Don't go.

I search. Only when I am anxious and too bored. In traffic, in line at the bank, waiting for a friend at a bar, my fingers follow instinct: Scroll. Scan. Search. It is an orphan's placebo.

I zoom into this neighborhood—lurching through the pixelated streets cobbled together by algorithms, where someone had cared enough about me to leave me. My body and my parentage were forsaken, and their parenthood was cleansed. Goddamn cold.

I'm gonna miss your love,
the minute you walk out that door.

II. Background Information

The foster family ██████████████████ ██████, by whom the child is well cared for at present, consists of six family members; foster mother ████████████ aged 42, who is a housewife, her husband ████████ ██████████████ aged 48, who is a merchant, and their two sons and two daughters, who are all students. ████████████████████████

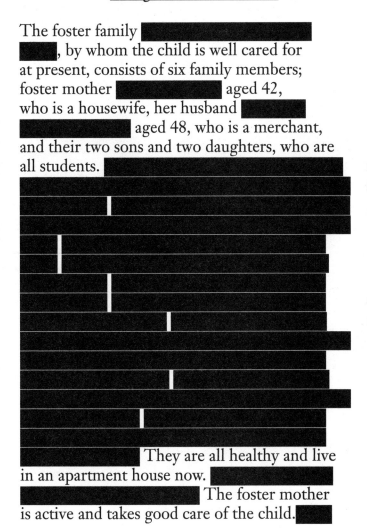

██████████████ They are all healthy and live in an apartment house now. ████████████ ████████████████████ The foster mother is active and takes good care of the child. ██████

This story begins in 1996, when my divorced mom married your single dad. Two only-children with the same parents. You, in Florida, would fly to us, in Seattle, several times a year—rotating holidays, six weeks in the summer, every

other spring break—in divorce, there's no such thing as "going Dutch." Divorced parents always fork out because loss is the soul of divorced parenting—no one stays. Most of my white friends growing up had divorced parents—they showed off their new kicks, clothes, phones, cash, and even cars that one parent provided, convinced the other parent wasn't stepping up— no one could afford it, though. The careful and complex symphonies orchestrated by divorce kids. Goddamn cold.

Parents and child are cleansed with
this love
we would pick you
up from the airport and go
straight to the mall.
If we bought you enough stuff—maybe you wouldn't go.

Don't go.

III. <u>Background Information</u>

0–6 months: ████████████████████
█████████ █████████████████████
███████ █ ██████████████████████
████████ █████████████████████

6 months–1 year and 3 days: Foster family ██
██
██
█████████████████████ I hope she will join a
good

adoptive family soon.

This story begins in 2008, when my brother was arrested in Seattle. He and some friends broke into three separate drug dealers' houses and stole their shit. "I just wanted the E and cologne," he explains years later, "I didn't care about the money." He just wanted the stuff.

"We didn't shoot anyone. The gun never went off. B pistol-whipped this dude. He told me to do it, but I ain't pistol-whippin' no dude. Have you ever heard that shit before? I didn't see him do it. I heard it crack his head. I ain't pistol-whippin' no dude," he said to me through the grimy phone receiver and smudged, thick protective glass between us during our first visit, when he was still in county. "B was like, 'Come over here and hit him, too, Red.' But I was like, 'NAH, I ain't hittin' no dude.'"

"They're saying ten to fifteen years," choking on his last words. The tears pour down his face, smearing the hundreds of freckles that mark him.

"The punishment doesn't fit the crime," the judge remarked at the sentencing, when he ruled Adam's seven-and-a-half-year sentence. "A young man from a good family, no record, and some college shouldn't be in prison this long, but a gun was present. Mandatory gun sentencing requires me to tack on five years that cannot be touched for early release."

He served seven and a half years hard time, at 19.

I hope she will join a good adoptive family soon

My mom, stepdad / your dad, and I longed for
you to live with us in Seattle. When you still
played T-ball and softball and went to summer
camp. And finally, at 18, your mom kicked you
out of the damp Florida air that weighs heavily
day into night and sent you to live with your dad
and his other family in the goddamn cold, gray
wetness of Seattle. Finally. But this was after
you had crashed your grandfather's car into a
canal, were arrested for dipping into your stash
before you passed out in class, got kicked out of
two high schools, came home drunk and peed

all over your bedroom, and other things the rest of us can cleanse ourselves of blame for because "well, boys sometimes do that."

So you came to live with your dad.

And your mom was cleansed. As a welcome, I printed about fifty *No Pee Zone* signs and taped them all over your room. In our family, our love is rough. Your dad laughed nervously when you saw the signs, his ceaseless torment is that we might push you away for good because our love is too hard. He doesn't understand that for kids like us, love that is hard is safer than being too soft.

You were still 110 pounds then, skinny—scrawny—and your bright-red hair was bleached from years in the oppressive Florida sun—you stood stark against Seattle's gray backdrop, your body had yet to shape-shift into its new home. When you got here, we clung desperately to legible markers of success—spinning narratives of middle-class well-being as if they proved to

everyone//ourselves that shit was cool—that your trouble was normal because, for the middle class, normal is life. "It's a big transition, but he's enrolled in college," or, "It's not easy, but we're looking forward to Thanksgiving with the family," or, "He's making so many new friends." This alleviated the heaviness of our darkness— the looming storm we could feel but not see. We were all animals sensing a coming trouble that we could not articulate any other way but to run with our entire might toward decorum.

Eight months with us before you were sent to prison.

And we were cleansed.

IV. Worker's Comment

She is a cute child. I hope
she will join a

 good

adoptive family
soon
and grow

under
much love.

This story begins in 1979 with my adoptive
parents, a young couple married at 24 and 23.

College lovebirds who discovered they couldn't have kids once they changed their minds about wanting them. It wasn't for a lack of trying—two years, to be exact—but not every life is the same success story.

They are not original. Like hundreds of thousands of other white couples, they adopted a baby from Korea—it was the safe adoption. It took about nine months and cost $5,000. They borrowed half from his parents, who happily laid out the loan with interest.

I hope she will join a *good*
 adoptive family

I was on a plane, with twelve other babies who were also being adopted into good families whose stories were not yet successes. I hope we cleansed them all.

You look just like me
my mom always says
you are my daughter

She was cleansed.

I've been to prison sixty-seven times. Every
time, I handed you back to the institution where

you could not escape, could not be saved, and where none of us is safe. We are two kids from the cleansing of parentage unto ourselves. We are of the system that does not care that each of us might bleed in our own way or that some of us think we bleed better because we do so in single-family homes with manicured hedges from good families.

This story may be only for you and me. It is about how we saved each other and pulled each other from the cracks in a system that is as much our oppressor as it is of our own making. It is how I visited you across thousands of miles, plane rides, car trips, and pat-downs so you would not spin so far into the cracks that you might fill them. This story is because the first time I met you, when you were nine and I was seventeen, you pulled me in from the goddamn cold—two single children from the same parents.

Babe, I love you so, I want you to know,
I love you so.

Please don't go.

Note

1. "Please Don't Go," on KC and the Sunshine Band, *Do You Wanna Go Party*, TK Records, 1979.

The Combahee River Collective Statement

During our years together as a Black feminist collective we have experienced success and defeat, joy and pain, victory and failure. We have found that it is very difficult to organize around Black feminist issues, difficult even to announce in certain contexts that we are Black feminists. We have tried to think about the reasons for our difficulties, particularly since the white women's movement continues to be strong and to grow in many directions. In this section we will discuss some of the general reasons for the organizing problems we face and also talk specifically about the stages in organizing our own collective.

The major source of difficulty in our political work is that we are not just trying to fight oppression on one front or even two, but instead to address a whole range of oppressions. We do not have racial, sexual, heterosexual, or class privilege to rely upon, nor do we have even the minimal access to resources and power that groups who possess any one of these types of privilege have.

The psychological toll of being a Black woman and the difficulties this presents in reaching political consciousness and doing political work can never be underestimated. There is a very low value placed upon Black women's psyches in this society, which is both racist and sexist. As an early group member once said, "We are all damaged people merely by virtue of being Black women." We are dispossessed psychologically and on every other level, and yet we feel the necessity to struggle to change the condition of all Black women. In "A Black Feminist's Search for Sisterhood," Michele Wallace arrives at this conclusion: "We exist as women who are Black who are feminists, each stranded for the moment, working independently because there is not yet an environment in this society remotely congenial to our struggle—because, being on the bottom, we would have to do what no one else has done: we would have to fight the world."[1]

Wallace is pessimistic but realistic in her assessment of Black feminists' position, particularly in her allusion to the nearly classic isolation most of us face. We might use our position at the bottom, however, to make a clear leap into revolutionary action. If Black women were free, it would mean that everyone else

would have to be free since our freedom would necessitate the destruction of all the systems of oppression.

Feminism is, nevertheless, very threatening to the majority of Black people because it calls into question some of the most basic assumptions about our existence, i.e., that sex should be a determinant of power relationships. Here is the way male and female roles were defined in a Black nationalist pamphlet from the early 1970s:

We understand that it is and has been traditional that the man is the head of the house. He is the leader of the house/nation because his knowledge of the world is broader, his awareness is greater, his understanding is fuller and his application of this information is wiser... After all, it is only reasonable that the man be the head of the house because he is able to defend and protect the development of his home... Women cannot do the same things as men— they are made by nature to function differently. Equality of men and women is something that cannot happen even in the abstract world. Men are not equal

to other men, i.e. ability, experience or even understanding. The value of men and women can be seen as in the value of gold and silver—they are not equal but both have great value. We must realize that men and women are a complement to each other because there is no house/family without a man and his wife. Both are essential to the development of any life.[2]

The material conditions of most Black women would hardly lead them to upset both economic and sexual arrangements that seem to represent some stability in their lives. Many Black women have a good understanding of both sexism and racism, but because of the everyday constrictions of their lives, cannot risk struggling against them both.

The reaction of Black men to feminism has been notoriously negative. They are, of course, even more threatened than Black women by the possibility that Black feminists might organize around our own needs. They realize that they might not only lose valuable and hardworking allies in their struggles but that they might also be forced to change their habitually sexist ways of interacting with and oppressing Black

women. Accusations that Black feminism divides the Black struggle are powerful deterrents to the growth of an autonomous Black women's movement.

Still, hundreds of women have been active at different times during the three-year existence of our group. And every Black woman who came, came out of a strongly-felt need for some level of possibility that did not previously exist in her life.

When we first started meeting early in 1974 after the NBFO first eastern regional conference, we did not have a strategy for organizing, or even a focus. We just wanted to see what we had. After a period of months of not meeting, we began to meet again late in the year and started doing an intense variety of consciousness-raising. The overwhelming feeling that we had is that after years and years we had finally found each other. Although we were not doing political work as a group, individuals continued their involvement in Lesbian politics, sterilization abuse and abortion rights work, Third World Women's International Women's Day activities, and support activity for the trials of Dr. Kenneth Edelin, Joan Little, and Inéz García. During our first summer when membership had

dropped off considerably, those of us remaining devoted serious discussion to the possibility of opening a refuge for battered women in a Black community. (There was no refuge in Boston at that time.) We also decided around that time to become an independent collective since we had serious disagreements with NBFO's bourgeois-feminist stance and their lack of a clear political focus.

We also were contacted at that time by socialist feminists, with whom we had worked on abortion rights activities, who wanted to encourage us to attend the National Socialist Feminist Conference in Yellow Springs. One of our members did attend and despite the narrowness of the ideology that was promoted at that particular conference, we became more aware of the need for us to understand our own economic situation and to make our own economic analysis.

In the fall, when some members returned, we experienced several months of comparative inactivity and internal disagreements which were first conceptualized as a Lesbian-straight split but which were also the result of class and political differences. During the summer those of us who were still meeting had determined the need to do political work and to move beyond

consciousness-raising and serving exclusively as an emotional support group. At the beginning of 1976, when some of the women who had not wanted to do political work and who also had voiced disagreements stopped attending of their own accord, we again looked for a focus. We decided at that time, with the addition of new members, to become a study group. We had always shared our reading with each other, and some of us had written papers on Black feminism for group discussion a few months before this decision was made. We began functioning as a study group and also began discussing the possibility of starting a Black feminist publication. We had a retreat in the late spring which provided a time for both political discussion and working out interpersonal issues. Currently we are planning to gather together a collection of Black feminist writing. We feel that it is absolutely essential to demonstrate the reality of our politics to other Black women and believe that we can do this through writing and distributing our work. The fact that individual Black feminists are living in isolation all over the country, that our own numbers are small, and that we have some skills in writing, printing, and publishing makes us want to carry out these kinds of projects as a means of organizing Black

feminists as we continue to do political work in coalition with other groups.

Notes

1 Michelle Wallace, "A Black Feminist's Search for Sisterhood," *Village Voice*, July 28, 1975, 6–7.

2 Mumininas of Committee for Unified Newark, *Mwanamke Mwananchi* [The Nationalist Woman] (Newark, NJ: Mumininias of CUN, 1971), 4–5.

Collages
by Mary Beth Edelson

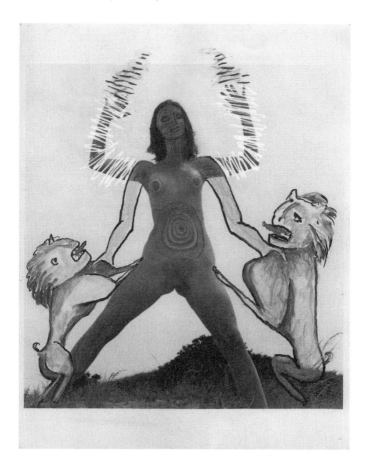

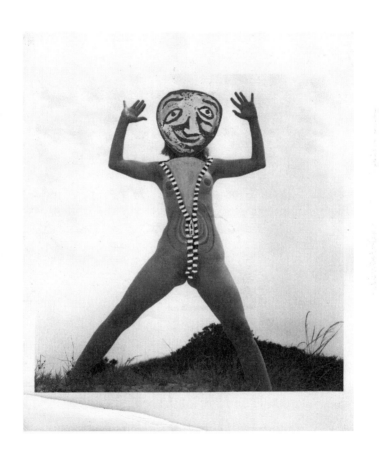

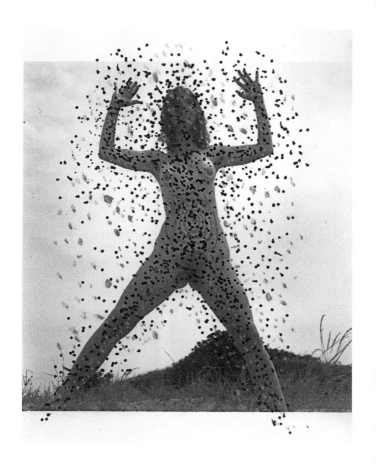

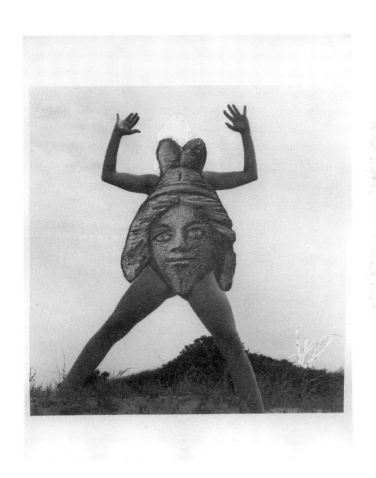

289

Sick Woman Theory
by Johanna Hedva

1.

In late 2014, I was sick with a chronic condition that, about every twelve to eighteen months, gets bad enough to render me, for about five months each time, unable to walk, drive, do my job, sometimes speak or understand language, take a bath without assistance, and leave the bed. This particular flare coincided with the Black Lives Matter protests, which I would have attended unremittingly, had I been able to. I live one block away from MacArthur Park in Los Angeles, a predominantly Latino neighborhood and one colloquially understood to be the place where many immigrants begin their American lives. The park, then, is not surprisingly one of the most active places of protest in the city.

I listened to the sounds of the marches as they drifted up to my window. Attached to the bed, I rose up my sick woman fist, in solidarity.

I started to think about what modes of protest are afforded to sick people—it seemed to me that many for whom Black Lives Matter is especially in service might not be able to be present for the marches because they were imprisoned by a job, the threat of being fired from their job if they marched, or literal incarceration, and of course the threat of violence and police brutality—but also because of illness or disability, or because they were caring for someone with an illness or disability.

I thought of all the other invisible bodies, with their fists up, tucked away and out of sight. If we take Hannah Arendt's definition of the political—which is still one of the most dominant in mainstream discourse—as being any action that is performed in public, we must contend with the implications of what that excludes. If being present in public is what is required to be political, then whole swathes of the population can be deemed *a*-political— simply because they are not physically able to get their bodies into the street.

In my graduate program, Arendt was a kind of god, and so I was trained to think that her definition of the political was radically

liberating. Of course, I can see that it was, in its own way, in its time (the late 1950s): in one fell swoop she got rid of the need for infrastructures of law, the democratic process of voting, the reliance on individuals who've accumulated the power to affect policy—she got rid of the need for policy at all. All of these had been required for an action to be considered political and visible as such. No, Arendt said, just get your body into the street, and bam: political.

There are two failures here, though. The first is her reliance on a "public"—which requires a private, a binary between visible and invisible space. This meant that whatever takes place in private is not political. So, you can beat your wife in private and it doesn't matter, for instance. You can send private emails containing racial slurs, but since they weren't "meant for the public," you are somehow not racist. Arendt was worried that if everything can be considered political, then nothing will be, which is why she divided the space into one that is political and one that is not. But for the sake of this anxiety, she chose to sacrifice whole groups of people, to continue to banish them to invisibility and political irrelevance. She chose to keep them out of the public sphere. I'm not the first to take Arendt to

task for this. The failure of Arendt's political was immediately exposed in the civil rights activism and feminism of the 1960s and '70s. "The personal is political" can also be read as saying "the private is political." Because of course, everything you do in private is political: who you have sex with, how long your showers are, if you have access to clean water for a shower at all, and so on.

There is another problem too. As Judith Butler put it in her 2015 lecture "Vulnerability and Resistance," Arendt failed to account for who is allowed in to the public space, of who's in charge of the public. Or, more specifically, who's in charge of who gets in. Butler says that there is always one thing true about a public demonstration: the police are already there, or they are coming. This resonates with frightening force when considering the context of Black Lives Matter. The inevitability of violence at a demonstration—especially a demonstration that emerged to insist upon the importance of bodies who've been violently *un*-cared for—ensures that a certain amount of people won't, because they can't, show up. Couple this with physical and mental illnesses and disabilities that keep people in bed and at home, and we must contend with

the fact that many whom these protests are for are not able to participate in them—which means they are not able to be visible as political activists.

There was a Tumblr post that came across my dash during these weeks of protest, that said something to the effect of: "shout out to all the disabled people, sick people, people with PTSD, anxiety, etc., who can't protest in the streets with us tonight. Your voices are heard and valued, and with us." Heart. Reblog.

5.

Sick Woman Theory is an insistence that most modes of political protest are internalized, lived, embodied, suffering, and no doubt invisible. Sick Woman Theory redefines existence in a body as something that is primarily and always vulnerable, following from Judith Butler's recent work on precarity and resistance. Because Butler's premise insists that a body is defined by its vulnerability, not temporarily affected by it, the implication is that it is continuously reliant on infrastructures of support in order to endure, and so we need to re-shape the world around this fact. Sick Woman Theory maintains that the body and mind are sensitive and reactive

to regimes of oppression—particularly our current regime of neoliberal, white-supremacist, imperial-capitalist, cis-hetero-patriarchy. It is that all of our bodies and minds carry the historical trauma of this, that it is the world itself that is making and keeping us sick.

To take the term "woman" as the subject-position of this work is a strategic, all-encompassing embrace and dedication to the particular, rather than the universal. Though the identity of "woman" has erased and excluded many (especially women of color and trans/nonbinary/genderfluid people), I choose to use it because it still represents the un-cared for, the secondary, the oppressed, the non-, the un-, the less than. The problematics of this term will always require critique, and I hope that Sick Woman Theory can help undo those in its own way. But more than anything, I'm inspired to use the word "woman" because I saw this year how it can still be radical to be a woman in the 21st century. I use it to honor a dear friend of mine who came out as genderfluid last year. For her, what mattered the most was to be able to call herself a "woman," to use the pronouns "she/her." She didn't want surgery or hormones; she loved her body and her big dick and didn't want

to change it—she only wanted the word. That the word itself can be an empowerment is the spirit in which Sick Woman Theory is named.

The Sick Woman is an identity and body that can belong to anyone denied the privileged existence—or the cruelly optimistic promise of such an existence—of the white, straight, healthy, neurotypical, upper and middle-class, cis- and able-bodied man who makes his home in a wealthy country, has never not had health insurance, and whose importance to society is everywhere recognized and made explicit by that society; whose importance and care dominates that society, at the expense of everyone else.

The Sick Woman is anyone who does not have this guarantee of care.

The Sick Woman is told that, to this society, her care, even her survival, does not matter.

The Sick Woman is all of the "dysfunctional," "dangerous" and "in danger," "badly behaved," "crazy," "incurable," "traumatized," "disordered," "diseased," "chronic," "uninsurable," "wretched," "undesirable" and altogether "dysfunctional" bodies belonging to women, people of color,

poor, ill, neuro-atypical, differently abled, queer, trans, and genderfluid people, who have been historically pathologized, hospitalized, institutionalized, brutalized, rendered "unmanageable," and therefore made culturally illegitimate and politically invisible.

The Sick Woman is a Black trans woman having panic attacks while using a public restroom, in fear of the violence awaiting her.

The Sick Woman is the child of parents whose indigenous histories have been erased, who suffers from the trauma of generations of colonization and violence.

The Sick Woman is a homeless person, especially one with any kind of disease and no access to treatment, and whose only access to mental-health care is a 72-hour hold in the county hospital.

The Sick Woman is a mentally ill Black woman whose family called the police for help because she was suffering an episode, and who was murdered in police custody, and whose story was denied by everyone operating under white supremacy. Her name is Tanesha Anderson.

The Sick Woman is a 50-year-old gay man who was raped as a teenager and has remained silent and shamed, believing that men can't be raped.

The Sick Woman is a disabled person who couldn't go to the lecture on disability rights because it was held in a venue without accessibility.

The Sick Woman is a white woman with chronic illness rooted in sexual trauma who must take painkillers in order to get out of bed.

The Sick Woman is a straight man with depression who's been medicated (managed) since early adolescence and now struggles to work the 60 hours per week that his job demands.

The Sick Woman is someone diagnosed with a chronic illness, whose family and friends continually tell them they should exercise more.

The Sick Woman is a queer woman of color whose activism, intellect, rage, and depression are seen by white society as unlikeable attributes of her personality.

The Sick Woman is a Black man killed in police custody, and officially said to have severed his own spine. His name is Freddie Gray.

The Sick Woman is a veteran suffering from PTSD on the months-long waiting list to see a doctor at the VA.

The Sick Woman is a single mother, illegally emigrated to the "land of the free," shuffling between three jobs in order to feed her family, and finding it harder and harder to breathe.

The Sick Woman is the refugee.

The Sick Woman is the abused child.

The Sick Woman is the person with autism whom the world is trying to "cure."

The Sick Woman is the starving.

The Sick Woman is the dying.

And, crucially: The Sick Woman is who capitalism needs to perpetuate itself.

Why?

Because to stay alive, capitalism cannot be responsible for our care—its logic of exploitation requires that some of us die.

"Sickness" as we speak of it today is a capitalist construct, as is its perceived binary opposite, "wellness." The "well" person is the person well enough to go to work. The "sick" person is the one who can't. What is so destructive about conceiving of wellness as the default, as the standard mode of existence, is that it *invents illness as temporary*. When being sick is an abhorrence to the norm, *it allows us to conceive of care and support in the same way*.

Care, in this configuration, is only required sometimes. When sickness is temporary, care is not normal.

Here's an exercise: go to the mirror, look yourself in the face, and say out loud: "To take care of you is not normal. I can only do it temporarily."

Saying this to yourself will merely be an echo of what the world repeats all the time.

6.

I used to think that the most anti-capitalist gestures left had to do with love, particularly love poetry: to write a love poem and give it to the one you desired seemed to me a radical resistance. But now I see I was wrong.

The most anti-capitalist protest is to care for another and to care for yourself. To take on the historically feminized and therefore invisible practice of nursing, nurturing, caring. To take seriously each other's vulnerability and fragility and precarity, and to support it, honor it, empower it. To protect each other, to enact and practice community. A radical kinship, an interdependent sociality, a politics of care.

Because, once we are all ill and confined to the bed, sharing our stories of therapies and comforts, forming support groups, bearing witness to each other's tales of trauma, prioritizing the care and love of our sick, pained, expensive, sensitive, fantastic bodies, and there is no one left to go to work, perhaps then, finally, capitalism will screech to its much-needed, long-overdue, and motherfucking glorious halt.

INDEX

1
Dust jacket

The image on the dust jacket is a video still from Patrick Staff's *Weed Killer*, 2017, single-channel HD video, color, sound, 16:49. Edition of 5 + 2 AP. Courtesy of the artist and Commonwealth and Council, Los Angeles.

2
I, etcetera
by Alex Kitnick

This essay was originally published in *October* 166 (Fall 2018), 45–62. © 2018 by October Magazine, Ltd. and the Massachusetts Institute of Technology.

3
We Bare Our Souls
by Anne McGuire and
Mike Kuchar

Film stills and texts in Anne McGuire and Mike Kuchar's *We Bare Our Souls* are from *Fur of the Field*, 1975; *Street Meat*, 2018; *The Season of Shadow and Flame*, 2018; *Broken Gods*, 2017; *Midnight Mass*, 2006; and *Flesh and the Stars*, 2017, by Mike Kuchar; photos, drawings, and *Fucked, A Short Poem* are by Anne McGuire; text and photo on pages 54–55 are from *the buddhist* by Dodie Bellamy; photo of Anne

McGuire on page 58 is by Eric Ruby. Original design is by Wayne Smith and Anne McGuire.

4
Starlings
by Lisa Robertson

This poem was originally published by Krupskaya Books (San Francisco, 2017).

5
A Situated Moment of Strain
by Nicole Archer

This text was commissioned for this publication and is previously unpublished.

Credits for the accompanying images are as follows: Christina Ramberg, *Waiting Lady*, 1972, acrylic on Masonite, 23 ½ x 32 ¼ inches, © Estate of Christina Ramberg, image courtesy of Corbett vs. Dempsey; Christina Ramberg, *Shady Lacy*, 1971, acrylic on Masonite, 12 x 11 inches, © Estate of Christina Ramberg, image courtesy of Corbett vs. Dempsey; and Christina Ramberg, *Probed Cinch*, 1971, acrylic on Masonite, 13 x 13 inches, © private collection, New York.

6
Osservate, leggete con me
by Frances Stark
(excerpt)

This text is excerpted from the three-channel video installation *Osservate, leggete con me*, 2012, 29:34, and is courtesy of the artist.

7
Feminist Snap
by Sara Ahmed
(excerpt)

This text is an excerpt from the
chapter "Feminist Snap," originally
published in *Living a Feminist Life*
(Durham, NC: Duke University
Press, 2017), 187–212. © 2017,
Duke University Press. All rights
reserved. Republished by
permission of the copyright holder.
www.dukeupress.edu.

Many thanks to Michele Carlson for
pointing us to this text.

8
Kin
by Marcela Pardo Ariza

These photographs are from the
2018 series *Kin* and are courtesy of
the artist.

9
Blanche and Stanley
by Dodie Bellamy

This essay was originally published in
Academonia by Krupskaya Books
(San Francisco, 2017).

10
Interior
by Thomas Clerc
(excerpt)

This text is an excerpt from *Interior*,
translated by Jeffrey Zuckerman
and originally published by Farrar,
Straus and Giroux (New York, 2018),
194–204.

Many thanks to Glen Helfand for
pointing us to this text.

11
Story of the Eye
by Georges Bataille
(excerpt)

This text is an excerpt from *Story
of the Eye*, translated by Joachim
Neugroschal and originally published
by Penguin Books (London,
1928/2012).

12
Kathy Acker's Clothes
by Kaucyila Brooke

Image captions are: *Untitled 3*, *75*,
118, *21*, *104*, *100*, *27*, *148*, *1*, *78*,
6, *69*, *85*, *93*, *94*, *110*, *115*, *123*,
128, *131*, *135*, *144*, *153*, and *155*;
Kathy Acker's Clothes, 1998–2004,
chromogenic prints, courtesy of the
artist.

13
Hold Me Now
by Glen Helfand

This text is a previously unpublished
excerpt from a forthcoming memoir.

14
Why?
by Bob Flanagan

This poem was originally written
for the exhibition *Visiting Hours:
An Installation by Bob Flanagan in
collaboration with Sheree Rose* at the
Santa Monica Museum in 1994,
where it was printed in a continuous
line on the wall, snaking around the
gallery.

15
Selections from Tammy Rae
Carland's Record Collection

These record covers were selected by
artist Tammy Rae Carland from her
extensive collection of recordings of
female comedians.

16
The Carrier Bag of Fiction
by Ursula K. Le Guin

This essay was originally published
in *DANCING AT THE EDGE OF
THE WORLD*, © 1989 by Ursula
K. Le Guin. Used by permission of
Grove/Atlantic, Inc. Any third party
use of this material, outside of this
publication, is prohibited.

Many thanks to K.r.m. Mooney for
pointing us to this text.

17
Uses of the Erotic,
the Erotic as Power
by Audre Lorde

This essay was originally published
in *Sister Outsider: Essays and Speeches*,
Crossing Press, © 1984, 2007 by
Audre Lorde; used herewith by
permission of the Charlotte Sheedy
Literary Agency.

18
Rosemarie Trockel
interviewed by Jutta Koether
(excerpt)

Jutta Koether's "Interview with
Rosemarie Trockel," was originally
published in *Flash Art* 134 (May
1987), 40–42.

The credit for the accompanying
image is: Rosemarie Trockel, *Untitled*,
1994, black crayon on lightweight
cardboard, 16.6 x 11.7 inches, ©
Rosemarie Trockel and ARS, 2020,
courtesy of Sprüth Magers.

19
Perverse or Artistic
by Julia Kristeva

This text is an excerpt from *Powers of
Horror: Essays on Abjection*, translated
by Leon S. Roudiez and originally
published by Columbia University
Press (New York, 1982), 15–17.

20
#AIMNOSTALGIA
by Juliana Huxtable

This text was originally published in
Mucus in My Pineal Gland, Capricious
and Wonder (New York, 2017),
44–48.

21
The Visits
by Michele Carlson

This text is a previously unpublished
excerpt from a forthcoming memoir.

22
The Combahee River Collective Statement

This text was originally published in *How We Get Free: Black Feminism and the Combahee River Collective*, edited by Keeanga-Yamahtta Taylor, Haymarket Books (Chicago, 2017), 21–26.

Many thanks to Trista Mallory for pointing us to this text.

23
Collages
by Mary Beth Edelson

Image captions are: *Artemis Series: Lion Tamer*, 1973, oil and ink on silver gelatin print; *Sheela's Undoing*, 1973, oil, ink, china marker, and collage on silver gelatin print; *Dematerializing/Trans - DNA*, 1975, oil and ink on silver gelatin print; *Trickster Body Series: Sunset*, 1973, oil, china marker, white out, and collage on silver gelatin print. All images are 10 x 8 inches, © Mary Beth Edelson, courtesy of the artist and David Lewis, New York.

24
Sick Woman Theory
by Johanna Hedva
(excerpt)

A version of Johanna Hedva's *Sick Woman Theory* was originally published by Mask Magazine in January 2016, edited by Hanna Hurr and Isabelle Nastasia, maskmagazine.com.

25
Ella Fitzgerald's scat singing, transcribed by Justin G. Binek

Ella Fitzgerald's transcribed songs appear as Appendix A in Justin G. Binek's *The Evolution of Ella Fitzgerald's Syllabic Choices in Scat Singing: A Critical Analysis of Her Decca Recordings, 1943–52*, PhD dissertation in Musical Arts, University of North Texas, 2017

Many thanks to Tonya Foster, whose lecture on scat singing inspired us to find these transcriptions.

—

Where are the tiny revolts?
(A Series of Open Questions, vol. 1)

Published by CCA Wattis Institute for Contemporary Arts
and Sternberg Press

Editors: Anthony Huberman and Jeanne Gerrity
Design: Scott Ponik*
Proofreader: Addy Rabinovitch

Printed and bound by Friesens (Manitoba), in an edition of 1500
Printed on Glatfelter Exbulk 50 lb.
Set in Janson Text

ISBN 978 3-95679-554-1

Distributed by The MIT Press, Art Data, and Les presses du réel

This book, the first volume of the Wattis Institute's annual A Series of Open
Questions readers, is a result of a year of learning from the work of
Dodie Bellamy in the company of reading group members Nicole Archer,
Michele Carlson, Tonya Foster, Lisa Heinis, Glen Helfand, Trista Mallory,
Anne McGuire, K.r.m. Mooney, and Marcela Pardo Ariza; and informed by a
series of public events. Special thanks to Dodie Bellamy, Kevin Killian,
Jeff Gunderson and the Anne Bremer Memorial Library of the San Francisco Art
Institute, Sheree Rose, Anne Ray, Cristiane Quercia Tinoco Cabral,
Nikita Dancel, and Jacqueline Francis.

Generous support provided by Robin Wright and Ian Reeves.

CCA Wattis Institute for Contemporary Arts
360 Kansas Street
San Francisco, CA 94103
www.wattis.org

Sternberg Press
Caroline Schneider
Karl-Marx-Allee 78
D-10243 Berlin
www.sternberg-press.com

Calen Barca-Hall, Head of Installation; Jeanne Gerrity, Deputy Director & Head of Publications; Anthony Huberman, Director and Chief Curator; Kim Nguyen, Curator; Christopher Squier, Operations Coordinator; Diego Villalobos, Exhibitions Manager

The CCA Wattis Institute program is generously supported by San Francisco Grants for the Arts; Wattis Leadership Circle contributors the Westridge Foundation, Penny & James Coulter, Lauren & James Ford, Jonathan Gans & Abigail Turin, Steven Volpe, and Mary & Harold Zlot; and by CCA Wattis Institute's Curator's Forum. Phyllis C. Wattis was the generous founding patron.

This reader is the first volume of an annual publication series,
A Series of Open Questions.

* Following *Walking on Splinters*; published by Werkplaats Typografie, Arnhem, 2004; edited and designed by Marijke Cobbenhagen, Joana Katte, Louis Lüthi, Janna Meeus, Radim Peško, Willi Schmid, and Maxine Kopsa. Thanks to Anniek Brattinga, Armand Mevis, and Maxine Kopsa.

Printed in Canada

Ella Fitzgerald's scat singing
Transcribed by Justin G. Binek

Cow Cow Boogie (solo fills)
November 3, 1943

Flying Home
October 4, 1945

bah dl oo dl ee dee doo.... dee oo dl ah voh dl ey loh dl ey loh dl

oh bee oot deet loht beep boo ihp boh...... dlee oot beet lahp doop boo ihp

"Mer - ri - ly, we roll a - long, on a deep, deep, deep, blue sea." Boo -

ee boo - ee boo - ee boo - ee boo - ee boo - ee boo - ee boo - ee boo -

ee boo - ee boo - ee booh boo ee...... boo dl oo boop bwee........ rihp

NOTE: upcoming grace notes indicate a flipped r consonant

dih oot leet laht lee bahp rihp dih oot leet laht lee bahp

dih oot leet laht laa bahp doo - ee daht dee boop boo bihp bwee........ dohn doo

doot doo dl oo diht doot boo yihp boot doo dl oo diht booee boo

313

D7

ee bah boop dee oo dlee mooh mooh mooh mah mah mah mahp "Wham!" boo-

CMa7 C/B♭ Ami7 G7 CMa7 C/B♭ Ami7 G7

oot doot dee boyt loo dee boyt doo duh lee dee doo dlee oo woh

CMa7 C/B♭ Ami7

boyt doo duh lee dee doo dl oo deel boyt dee doo dl ee dee dih dl ee boy boot

dee doo dl ee dee dih dl ee boy boot dee doo dl ee dee doo dl ee dl ih dih___ dl ih dih

CMa13

dl ih dih dl ih dih bah rihp

315

Oh, Lady Be Good
March 18, 1947